CAPTURING
Light & Color
WITH PASTEL

DOUG DAWSON

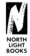

NORTH LIGHT BOOKS Cincinnati, Ohio

99 98 97 96 95 5 4 3 2 1

Library of Congress Cataloging in Publication Data

Dawson, Doug
 Capturing light and color with pastel / Doug Dawson.—1st ed.
 p. cm.
 Includes index.
 ISBN 0-89134-678-3
 1. Pastel drawing—Technique. 2. Light in art. 3. Color in light. I. Title.
NC880.D35 1991
741.2'35—dc20 91-6439
 CIP

Edited by Greg Albert and Rachel Wolf
Designed by Clare Finney

To the great creator, the God of Abraham, Isaac, and Jacob. Before I was born you knew me. You gave me a gift. More important, you gave me the will and opportunity to develop it.

To my wife, Sue. I am an artist today because you believed in me, encouraged me, and sacrificed your own desires and ambitions so that I could paint. To my parents, Joe and Sara Dawson. I believe in myself because you believed in me. To my parents-in-law, David and Dorthy Kemper. You encouraged us when I know you were afraid for our future.

To artists Ramon Kelly, Paul Kowtney, and Ned Jacob. I learned much about art and discipline from you.

To Gene Smith, a past student of mine. You made writing this book much easier by providing two years of notes from my lectures and demonstrations.

To you, my friends and family, I dedicate this book. Thank you!

Doug Dawson

Introduction

This book is about how to paint with pastel. More than that, it is about how to paint in general, with emphasis on pastel. With some adjustments, the techniques and methods demonstrated in this book will work with any opaque medium, liquid or dry. This includes hard pastel, oil pastel, oil, acrylic, gouache or casein.

The great truths in science, religion and art can all be expressed simply. My own study of art is a search for those great simple truths. This book is a summary of what I have found. I have tried to present the material as clearly and simply as possible so that it will be useful to the beginner; yet I kept the content meaty so it will challenge the advanced student.

Pastel is the single best medium to use for learning about color. Because you can't mix it on a palette, it forces you to try combinations of colors on the painting surface. In the process you make discoveries you would never have made otherwise.

Each painting is a puzzle that must be solved. The task of the artist is to find solutions to his own puzzles. The art of painting is the art of problem solving. There are sensible ways to search for solutions to problems and ways that waste time, cause aggravation, and result in failure. Each chapter describes problem-solving techniques for different types of problems, and in the last chapter I describe how to search for new ideas and directions in your art.

Of all the thoughts in this book the most important one, the one that is central to all the others, is that *a drawing is organized with line, but a painting is organized with shapes*. Painting is not simply the activity of filling in a drawing like a coloring book. There are two fundamentally different ways to paint. I look at each of these methods, and at how they can be combined with each other and with drawing. My hope is that this book will become a source of information and inspiration to you in the search for your own artistic expression.

◀ "Pam" 15½" × 13½"
Collection of Daniel D. Watt

Materials and Equipment

There are many different kinds and qualities of pastel sticks available today. In my work I use only soft pastels, which give the rich, paint-like textures I prefer. There are several good brands, and generally, you get what you pay for.

Rather than buying a set of pastels, I put together my own set, tailoring it to meet my needs. My selection includes soft pastels from many different brands. I started my set by going to a local art store and picking out a dark, middle and light value of about a dozen colors. From then on, whenever I needed a new color I would buy a dark, middle and light value of that color. In this way, my set grew in its spectrum of colors as well as its range of values.

► **"Bridge in the Cottonwood"** 19″ × 21″
Soft pastel on Masonite board

The equipment I use is the following:

An easel: I prefer an easel to a table. On an easel the pastel dust falls away from the painting's surface. With a table it just lies there getting in the way.

Drawing board: I use a piece of ⅛-inch Masonite.

Masking tape or clips: I prefer to use a piece of tape across each corner to hold the paper on the board.

A bristle brush: This is handy for brushing pastel away if it needs to be removed. It works equally well on paper or sanded board.

Fine sandpaper: This may be used to remove pastel on paper and at the same time rough up the paper so it is receptive to pastel again.

A selection of soft pastels: I recommend a dark, middle and light value of each of the colors you choose. If you start out with a small set, expand it so that you have a dark, middle and light value of each color in the set.

When I buy a new stick of color, I cut a slit in the paper and break off a piece of pastel about a half inch long. I keep the pieces of pastel on a porcelain plate next to my easel. The sticks are stored in a drawer until I need more of a particular color. Save the papers. They have codes on them identifying the hue and value of each stick.

I store and transport my pastels in rice flour. The pieces of pastel are placed in a basket made out of heavy window screen. This basket in turn is placed inside a coffee can and rice flour is poured over the pieces. The rice flour cushions them, preventing breakage during travel. It also rubs against them, removing the gray dust

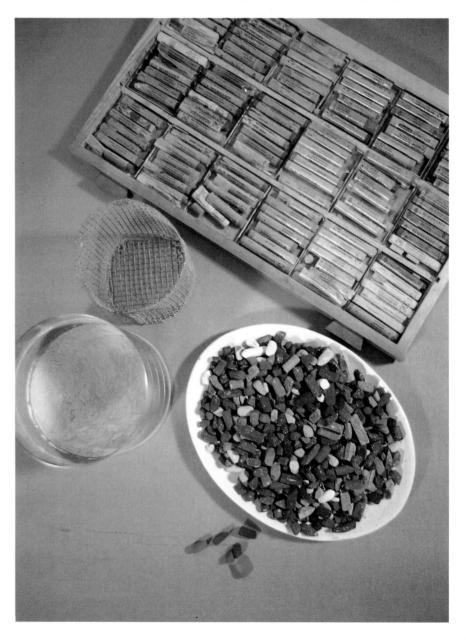

▶ This shows my pastels stored in drawers; pastels set out on my porcelain plate; the coffee can, wire basket and rice flower that I use to transport my pastels; and a small group separated out as a palette.

Many of my students like to use compartmentalized trays such as muffin tins to organize their pastels. The advantage to having an organized tray is that you know exactly where everything is. I prefer my plate for the opposite reason. I don't want to know where each color is. If my pastels were neatly arranged, I would be too tempted to use the same color solutions for everything. Looking down at a haphazard plate of colors I am often struck by a color that I would never have thought of using.

I don't use hard pastels, pastel pencils or stumps in my work. All the paintings in this book were done with soft pastels.

One of my students uses cornmeal instead of rice flour with equal success. I have seen others use whole grain rice, but this doesn't work as well.

that can cover them after some period of use. When I am ready to use the pastels I just sift the rice flour out, dump them back onto my plate, and I'm ready to work.

My Palette

My palette is made up of the colors I select from the plate. I set these pieces aside on my easel. At first my palette is simple and consists of only two or three pieces. As the painting progresses more pieces are added. Separating the pieces isolates them from the rest so they are easier to find and so they don't get confused with all the other colors.

Methods of Application

Pastel can be applied with the tip for linear strokes, with the side for broad, flat strokes, or as a powder, sprinkled on or applied with the touch of a finger. You can't mix pastel colors the way you can mix a liquid medium. Pastels can only be mixed by painting one layer over another. When two colors are layered, the results will differ depending upon which color is on top and which color is on the bottom. Pastel can be blended by working one stick of color into another, or by rubbing with a finger, stump or tissue. They can be moved around by painting into them with water or turpentine.

Removing Pastel

If the pastel gets too heavy and I need to remove some, I whisk it away with a bristle brush. Use this method on paper or board. Sometimes the pores of the paper become so filled with pastel that slick, shiny spots develop. If this happens, the bristle brush won't help. What has happened is that the tooth of the paper has been crushed by repeated applications of pastel. These

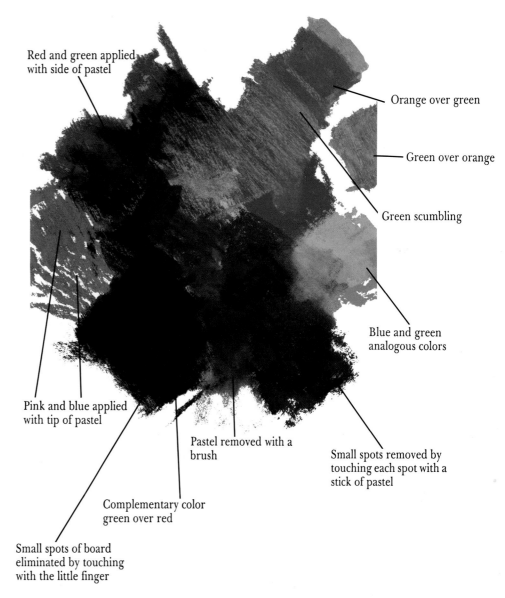

Red and green applied with side of pastel

Orange over green

Green over orange

Green scumbling

Blue and green analogous colors

Pink and blue applied with tip of pastel

Pastel removed with a brush

Small spots removed by touching each spot with a stick of pastel

Complementary color green over red

Small spots of board eliminated by touching with the little finger

spots can be revitalized and the pastel removed by gently sanding them with a piece of light sandpaper. But don't use sandpaper on a sanded board. The sandpaper will remove the sandy surface from these boards.

The Surface

Spots of paper or board showing through in the finished painting are troublesome, particularly in the darker passages of the painting, where they are very bright by contrast. They look like snowflakes all over the surface of the painting. To eliminate

▲ Here are examples of different applications of pastel. Pastel is the best material you can use to learn about color because it forces you to try new combinations of colors. You can't premix the color as you can with oil paint, so your only alternative is to try combinations of colors on the painting's surface. When you do this, you can make exciting discoveries.

them, I either touch each spot with a stick of pastel, or I remove them with short strokes of my little finger. Be careful; don't rub large areas of the painting with your finger. This type of rubbing destroys textures, causing the painting to go flat. I use short, staccato strokes of my finger, just long enough to wipe out each spot. The spots are even more objectionable on white paper, because they are brighter. For this reason it is best to work on a toned surface. *Avoid white paper.*

Fixative

Fixative causes the light values to darken and the colors underneath to bleed through to the surface. Which colors will bleed and which colors won't is unpredictable. Therefore, it is not wise to seal a finished painting with a fixative. If you are going to use fixative, use it only to seal coats of pastel you intend to cover with an additional coat. Instead of spraying a finished painting with a fixative, I strike the board several times on the back. These blows knock off any pastel that is loose enough to fall off later. Beating the back of the board can result in small open areas where pastel has fallen off the paper or board. These areas are easily retouched before framing.

Paper and Board

The paintings in this book were done on Canson paper, etching paper or Masonite board. Of the Canson papers, I prefer the lighter brown or gray tones. I avoid the dark papers and brightly colored ones. The front side of the Canson has a screenlike texture that I find objectionable. I prefer the back side, which is smoother. While any etching paper will work, I prefer the texture of German etching. I tone the etching papers with accidental washes of acrylic or casein.

◀ This shows the application of pastel on the front side of Canson paper. This side has a readable watermark and a texture that vaguely resembles a wire screen. Some people like this texture. I find it objectionable because it is so mechanical looking. If a texture is going to show up, I prefer that it be irregular. Since almost all my work is built up with multiple layers of color, I used multiple layers in the tests. I wanted to see not only what the texture looked like where the paper shows through but also how it affects the appearance of the upper layer of colors.

▶ This is an example of pastel tests done on German etching paper. The texture is irregular. As they did in the tests done on Canson, the colors here blend softly with each other.

◀ This test shows the application of pastel on the back side, the smooth side, of a piece of Canson paper. The grain that shows up is irregular. The layers of color have a soft appearance.

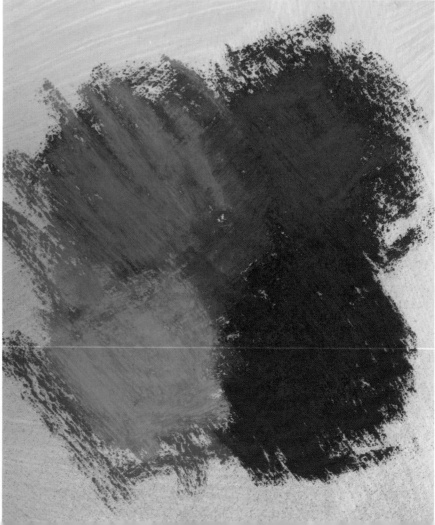

▶ This last test is done on Masonite board covered with gesso acrylic and a final layer of acrylic gel medium and pumice. The texture is also irregular. The edges of the colors are a little sharper where they overlap.

These papers are fun to use when I intend to let the paper show up in the finished piece. Most of my work is done on Masonite with a pumice ground. These boards are similar to some of the commercially made sanded boards, except their surface texture is more exciting. The painting *Bridge in the Cottonwood* was done on Masonite board.

Preparing Boards with a Pumice Ground

I prepare the Masonite boards as follows: First I cover them with three coats of gesso. I alternate the direction of each coat to eliminate any texture and to keep track of where each board is in preparation. The first coat is vertical, the second horizontal, the third vertical again. I can look at the direction of the last coat on any board and tell whether it is coat number one, two, or three. Second, I tone the board. This is usually done with acrylic paint, using a mixture of raw umber, cobalt blue, and titanium white. Depending upon how much blue or raw umber I use, the boards turn out either gray or brown. The acrylic tone is applied using alternating diagonal strokes. Last of all, I coat the board with a layer of acrylic gel medium mixed with pumice. I use one part pumice to two parts gel medium by volume. I also apply this coat with diagonal strokes because the texture is richer and more exciting than that of vertical and horizontal strokes. This is important; these last two coats may show up as textures in the finished painting.

A painting done on paper must be attached to a backing board for framing. Masonite is too heavy to attach to a backing board, so I prepare each board to serve as both the ground for the painting and the backing board. I tape off a 3- to 4-inch margin around each board using box sealing tape. This space will be covered later by the mat. I use a 3½-inch mat on the smaller pieces and 4-inch mats on the larger ones. An advantage to taping the boards is the insight I get when I pull off the tape at the end of the painting process. When I remove the tape I see the painting for the first time against a clean white margin. The impact of this draws attention to those parts of the painting that are not working and those parts that are still not finished.

▼ This shows the different stages in the preparation of a Masonite board and the materials used from bottom to top.

I also keep a few Masonite boards around that haven't been toned or covered with gel medium and pumice. Instead they have just three layers of gesso on them. I use these boards for paintings that are begun as acrylic or casein paintings and finished as pastels. I carry the acrylic or casein part of the painting as far as I wish.

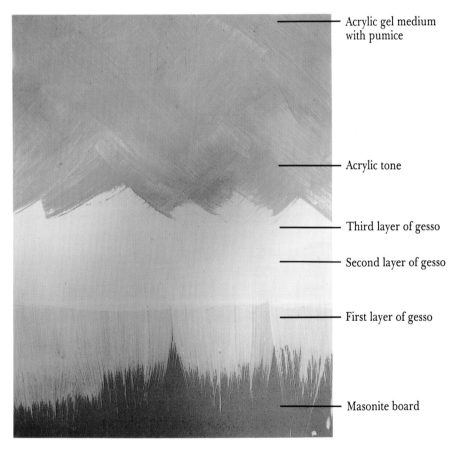

Acrylic gel medium with pumice

Acrylic tone

Third layer of gesso

Second layer of gesso

First layer of gesso

Masonite board

Preparing Accidental Surfaces

An accidental surface is a random pattern of value and color that is the result of applying color to paper to allow accidental visual textures to occur. The medium I usually use for this is either acrylic or casein. I might drip turp into an acrylic wash, pour salt, tilt the board, apply a wash with sponges, or print from a flooded paper.

There are an endless number of ways to prepare an accidental surface. Regardless of the method used, good accidental surfaces share some common characteristics. First, the surface must remain receptive to pastel. Don't use materials in such a way as to fill up the tooth of the paper or the paper will not be receptive to pastel. Second, avoid dominant textures such as mechanical or geometric patterns with hard edges. Wet into wet techniques work well for accidental surfaces because they produce soft, flowing edges. I try to keep a dozen or so of these papers with accidental surfaces on hand.

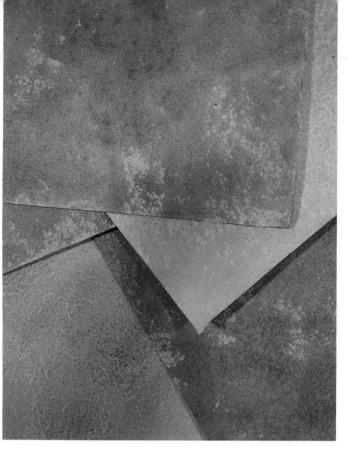

▲ I use accidental surfaces when I want to do a vignette, a painting where part of the paper is left visible in the finished piece.

Framing Pastels

There are two problems specific to framing pastels. The first problem is to prevent pastel dust from fogging the glass or Plexiglas. The second problem is to prevent pastel dust from flaking off the painting and soiling the mat.

To prevent pastel from fogging the glass, I separate the painting and the glass with a visible mat. With Plexiglas, I also clean the surface with an anti-static cleaner. To prevent pastel dust from falling off the painting and soiling the visible mat, I separate the visible mat and the painting with a hidden mat. This slight gap between the painting and the visible mat acts like a dust catcher. Pastel particles that flake off the painting surface fall into this space, thereby keeping the visible mat clean. See the drawing of the hidden mat.

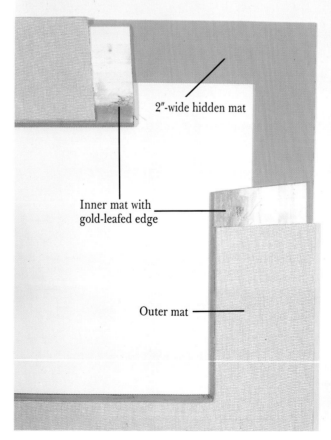

2"-wide hidden mat

Inner mat with gold-leafed edge

Outer mat

▲ Here's a cutaway view of the visible mat and the hidden mat.

T W O

Understanding Pastel Painting

Pastel has certainly gained the respect as an art medium that it has long deserved. However, there is still some confusion when we speak of pastel *painting*, because pastel, as a dry medium, has usually been considered a *drawing* tool.

What is painting? Painting is the activity of organizing a piece of art with shapes. Drawing is the activity of organizing it with line. A drawing starts with an unordered blank paper. As each line is added the paper becomes more organized, until a final state of order is achieved and the drawing is completed. A painting starts with the same lack of order as a drawing, but is organized with shapes. Shapes are changed and corrected by overlapping the edges of shapes. When the desired degree of organization is achieved, the painting is done. Traditionally painting has been associated with liquid media such as oil, and drawing with dry media such as pastel. The question of whether we are drawing or painting, however, is not a question of whether the medium is wet or dry, but of whether we are building with shape or line.

▲ **"Old Lady in Hat"** 11″ × 15″
Collection of Lillian Dawson Kemper

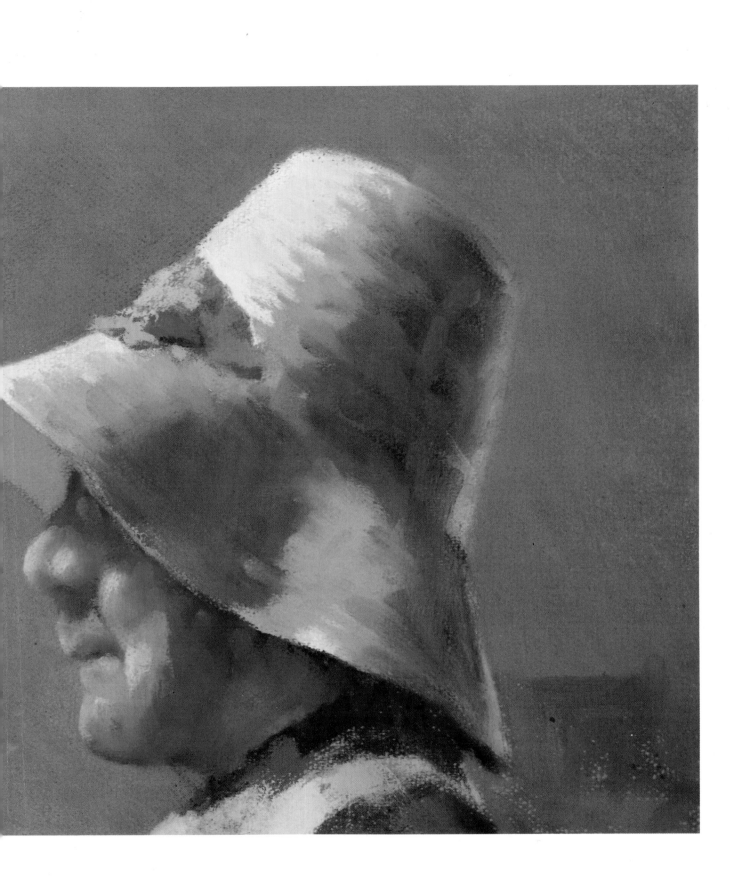

Important Painting Guidelines

Let the Subject Dictate the Size and Proportions of the Board

If I do a character study, as I did here, the head needs to be large enough to develop the features. That means a head which is at least 3 to 4 inches long, preferably longer. I determine the size of the board based upon whether I am painting the head, the head and shoulders, or the head and whole body. Whether composition dictates size or size dictates composition, the size of the board and the artistic problem should be suited to each other.

Take Advantage of the Way Light and Shadow Sculpt the Form of Objects

In *Benjamin*, I positioned the light on the model in front and to one side. In this light, his nose cast a shadow that fell across his moustache and mouth, giving his face solidity. Avoid flat light, such as the light of an overcast day or of photographs taken with a flash. The changes in value and hue in flat light are subtle and difficult to interpret. Give yourself simple light and shadow problems.

Paint What You Are Interested In

If you can't get excited about it, don't paint it. When you aren't interested, it is very easy to give up the second there's a problem. My interest in a subject sustains me and keeps me motivated to solve the problems and finish the piece. This is even true of classroom demonstrations. I find it easier to do a successful demonstration when I am interested in the subject. For that reason, I often go to class prepared to either give a painting demonstration or talk about something else. The day I painted *Benjamin* I was planning to talk about toning papers. When I saw the model I decided to do a demonstration instead.

Look for a Point of View

Ask yourself what you want to say about the subject. When painting a person I ask myself whether I am responding to the body language, in which case I paint the whole figure, or to the character or expression, in which case I paint the face or head as I did in *Benjamin*. I may be responding to the design, in which case I try to identify the important elements in the design. In this painting, my interest immediately drew me into the face.

As the Painting Develops, Let it Begin to Take on a Character or Identity of Its Own

This character is inspired by the subject yet is different from the subject. The model who sat for *Benjamin* was bald. His baldness was an important part of what interested me and the feelings I had when I looked at him. After some work, however, I paused and found that the painting had gone in a different direction. It was inspired by him, yet without the top of his bald head it had a different feeling. I could have rejected that feeling and made the painting look more like him. Indeed, I would have, had it been a commissioned portrait. I chose not to. I chose to finish the painting for what it had become. This can happen several times in the course of a painting. The painting takes on a character, the artist rejects it. It takes on a second character, again the artist rejects it. Remember, however, that as an artist your task is to express new and personal insights into the world. If you fail to do that, if you treat yourself as only a camera, you are at best a craftsman. The title "Artist" doesn't come with the purchase of art supplies; it must be earned. To be an artist is a commitment to a never-ending search for a personal or unique vision of the world.

For a Painting to Be Finished It Must Be Unlabored, Balanced and Integrated

Unlabored, in that each shape is purposeful. Each shape must have the right contour, the correct hue and value. The colors are not dirty. Balanced, in that all the shapes and colors work well within the margins of the picture. Integrated, in that all the techniques and methods go together. The simplest way to integrate a painting is to stick with one method of applying pastel, as I did in this painting. Finally, there should be variety within the painting to create interest. More detail is *never* the solution to finishing a painting.

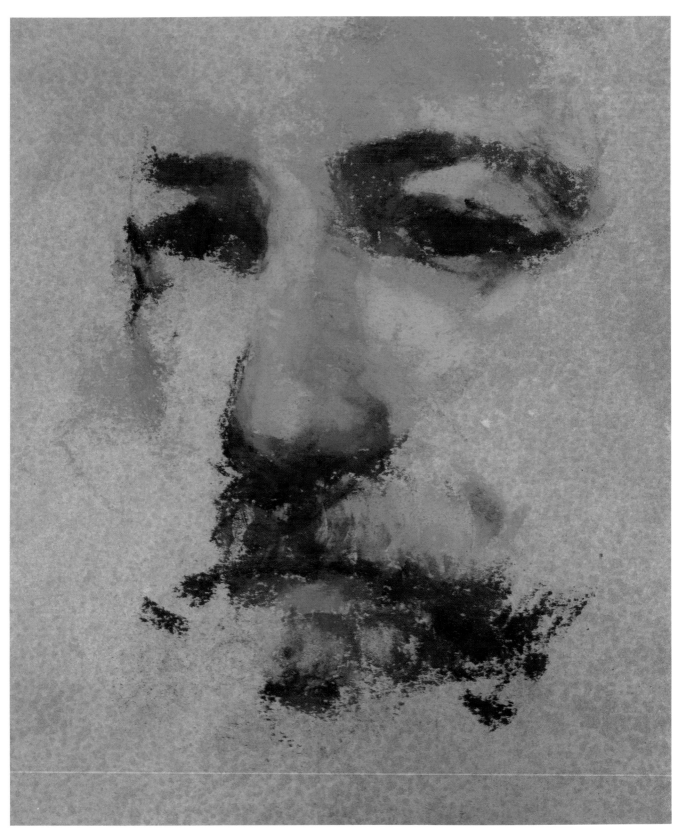

▲ "Benjamin" 8½″ × 8″

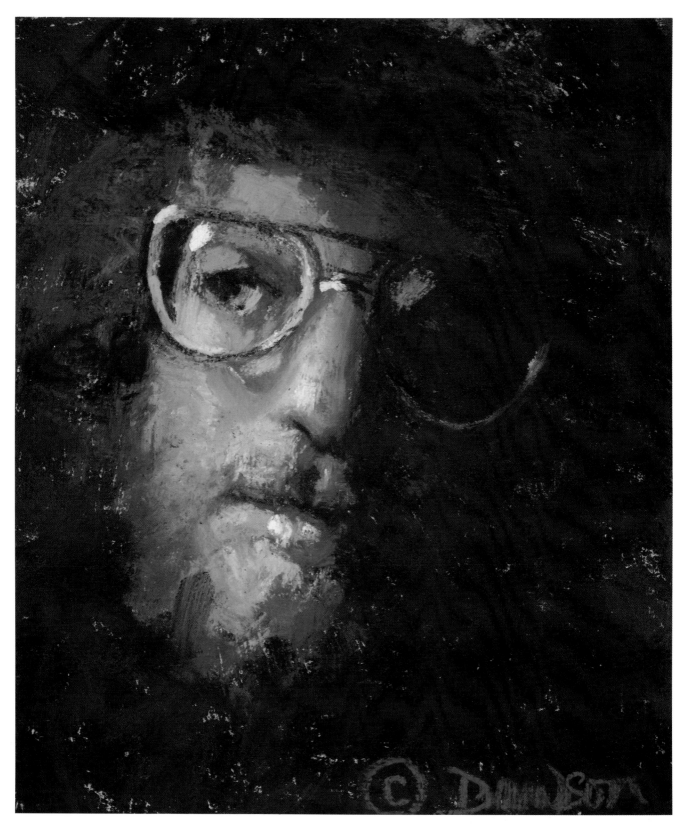

▲ **"Study of Kevin"** 8″ × 7″
This painting is an example of blocking in the
big shapes and breaking them down into
smaller shapes.

Two Basic Approaches to Painting

There are two basic methods of painting. Both of these methods have characteristic strengths and weaknesses, as does drawing. Each approach will be discussed in detail in Chapters Three and Four. The pencil illustrations on pages 16 and 17 compare the two methods of painting with drawing. The ultimate painting skill is to understand drawing and painting so well that you can freely alternate between methods as you work.

The first approach to painting I call **working from big to small shapes**. *Study of Kevin* is an example of this approach. The first step in this approach is to block in the whole painting with just a few large shapes. After these large shapes are blocked in, they are divided up into middle-sized shapes. These middle-sized shapes are usually the large shadow shapes and the large light shapes within each object. The third step is to subdivide the middle-sized shapes into smaller shapes. The procedure of dividing the shapes continues until the desired degree of detail is achieved. Depending upon where you stop in this process, the finished painting will look either abstract, impressionistic or photographic.

The second approach I call **working from shape to shape** or **puzzle painting**. *Benjamin* is an example of this approach, as is *Study of Tom*. In puzzle painting, the painting begins with one small shape of the correct value. Then a second shape of correct value is added next to the first. Then a third shape is added to the other two, then a fourth shape, and so on until the painting is complete. It is just like putting a jigsaw puzzle together. If the shapes are big the painting looks impressionistic, and if the shapes are very small it will look photographic.

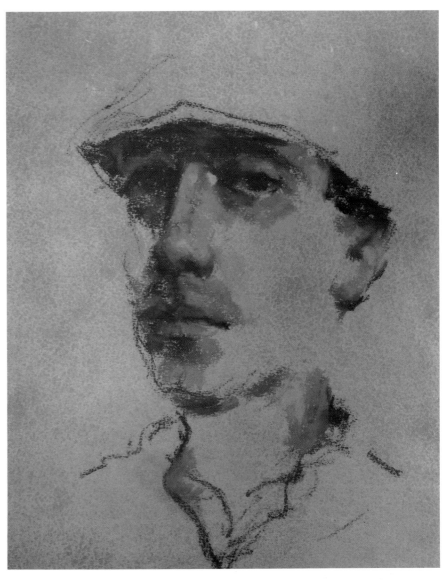

▲ **"Study of Tom"** 12″ × 10″
This is an example of puzzle painting. The painting is put together one little shape at a time.

Demonstrations of the
Three Basic Methods of
Applying Pastel

▶ **Drawing**
Actually, there are many different approaches to drawing. For my purposes I will treat all drawing as one process. Lines are added one at a time until the drawing is organized. At that point it is finished.

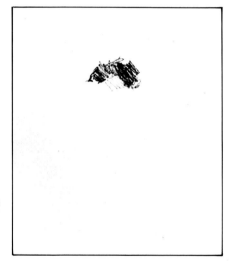

▶ **Painting Shape to Shape (Puzzle Painting)**
Small shapes are added like putting pieces of a puzzle together. Each little shape is the correct color and value (see Chapter Six). This is continued until the painting is finished.

▶ **Working from Big to Small Shapes**
Large shapes are blocked in, then these shapes are divided into smaller shapes and those into still smaller shapes. This process continues until the desired degree of order is achieved and the painting is finished.

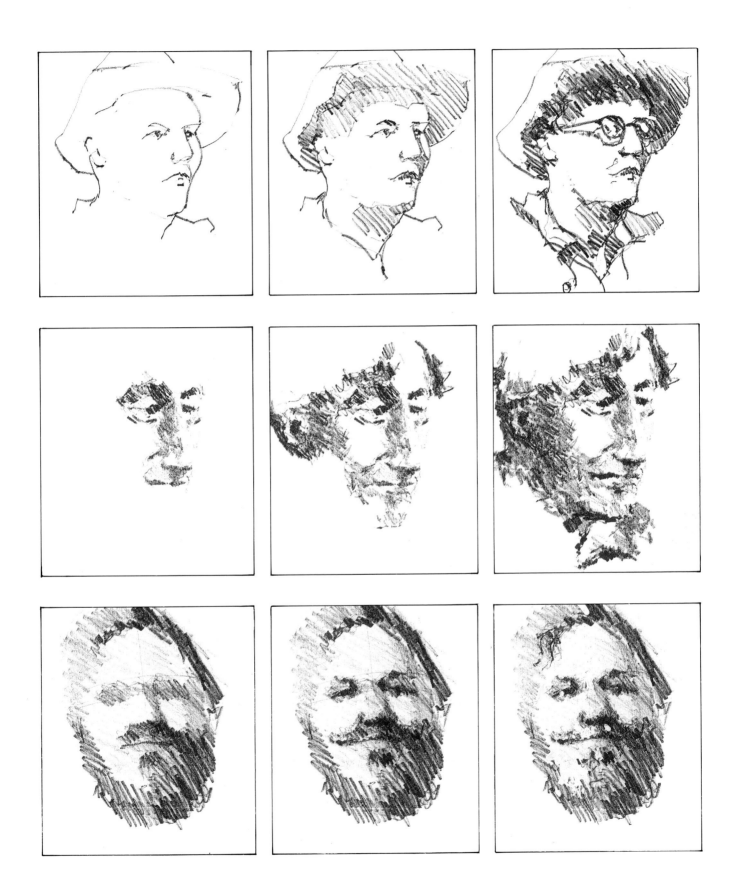

Working from Big to Small Shapes

There are two main advantages to working from large to small shapes. First, working this way forces you to visualize the composition in terms of big shapes. The large shapes and value patterns are the primary elements in any composition. By placing the large shapes first, you see the composition immediately, and you know whether it will work or not. The large value patterns within these large shapes establish the atmosphere or feeling of the painting. Because the value patterns are blocked in early, the mood of the painting is established early. It is easier to maintain a mood or feeling already established than to build toward one hoping it will materialize. Second, the loose, quickly applied strokes used to block in the big shapes give the painting energy and excitement. I find it easier to maintain my interest in a painting when I am excited about it. I am less likely to give up on it, more likely to stick it out and find solutions for the rough spots. Beginning a painting this way is like starting a go-cart at the top of a hill. The steeper the hill, the more exciting the ride. I like to start a painting with enough energy to maintain my excitement, but not so much that I lose control and crash.

My only caution about working this way is that if you aren't careful, you may fill up the paper or board with pastel before the painting is completed. Through practice you learn to avoid this problem. You learn to lighten up on the first few layers of pastel and thereby avoid filling up the pores of the paper.

▶ **"Becky"** 12½″ × 10½″
Collection of R. Messman

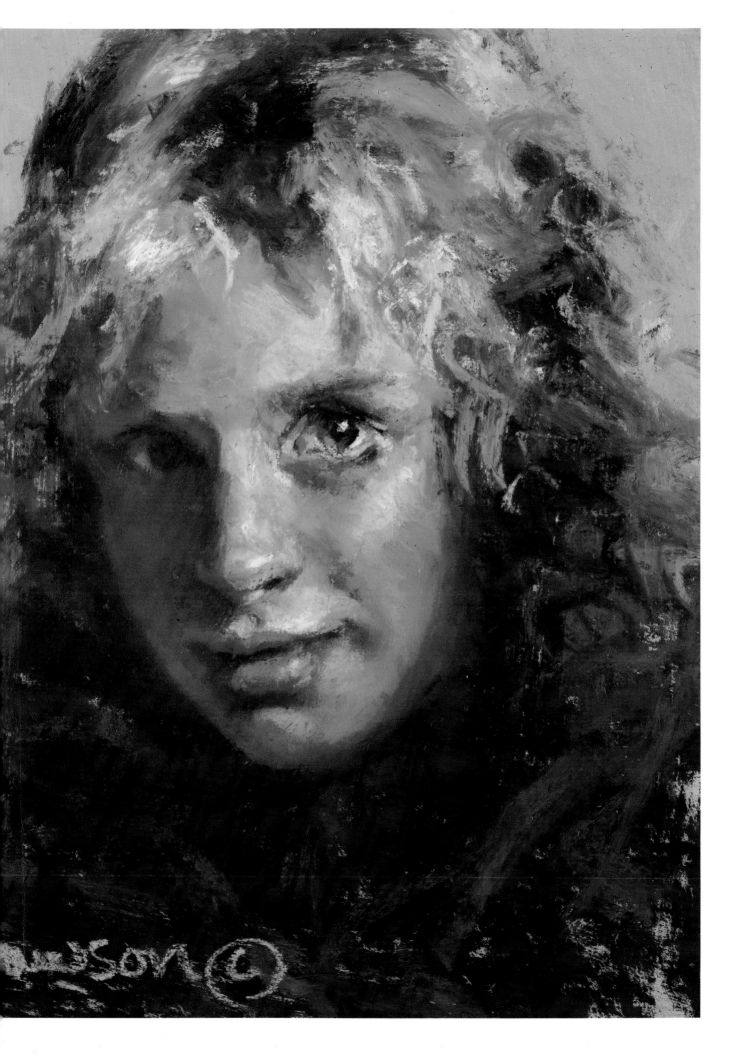

Block In the Big Shapes

For the initial block-in, I select values that are two or three steps apart on the value scale. I block in each large shape with a value that is halfway between the light and shadows of that area, a value that might be called the local tone.

If I am blocking in a very light object, such as a white shirt, I block it in using the hue and value of its shadow. I avoid beginning a painting with a very light value because I will have to work over it, and *working over very light values is a recipe for muddy color.* For other shapes, I choose sticks that are halfway between the lights and shadows so I can add color without creating mud.

The three colors I select in the beginning set the direction for the painting. They could be representational of what I am seeing, or they could be totally different. What I choose depends on what is important in the finished painting, what I want to draw attention to. In the painting *Emily*, the subject's blouse was red. I blocked it in with blue-green. I was afraid that too much red would overpower the center of interest, which is her face. By using blue-green underneath, I hoped to control the red. I expected the blue-green to mix with the red, in some places making it duller and in other places standing out in contrast against the red, making those small spots of red seem brighter.

These big shapes are the most important ones in the composition. By placing them first, I can visualize how the finished painting will look. At this stage, the painting should be a pleasing abstract arrangement of shapes. If I like the composition I go on; if I don't I change it. I liked the arrangement of shapes in *Emily*, so I continued.

▲ I begin by blocking in the whole painting using the biggest shapes possible. I do this with three sticks of pastel: a dark, middle, and light value. In *Emily* I blocked in her face with burnt sienna. The stick I used was darker than the light side of her face and lighter than the shadow side. I blocked in her face, neck and arms with the same stick even though they are separated from each other by cloth and seem to be slightly different in color. I did this because they are made of the same substance, her skin. I placed a small dot on the bottom of her chin to help me visualize where the head ends and the neck begins.

Divide the Big Shapes

After the big shapes are blocked in, I divide them into the large simple shadow shapes (dark) and large simple light shapes. I could do this by either blocking in the shape of the shadow over the large shape, as I did in the painting of *Emily*, or by blocking in the shape of the light. Both methods will divide the large shape into light and shadow. The first approach works best in one situation, the second approach works best in another. These large light and shadow shapes are then divided into smaller, intermediate shapes.

When I add a new shape, I look for other places in the painting where that same color or colors can be used. This helps keep my palette simple. I used the same reds on Emily's lips as I did on other parts of the face and neck where the shapes were warm. I used the same stick of permanent red light to block in the mouth above the upper lip and on other parts of the neck and face where the shapes were light. There is a great temptation to use a different stick of color for each new shape. Unless I consciously resist that temptation, I can have too many colors going too fast, and the painting will be out of control.

▲ Large simple shapes denoting shadow areas divide the foundational shapes.

▲ Here I blocked in the intermediate shapes. Using one color of red I blocked in the shape of her ear, the upper eyelid, the lips (treated as one shape), the chin and edge of her jaw, the forehead, and cheek. Similarly, I started to divide up the shadow side of her face. I redefined the shape of the shadow under Emily's nose and her eyebrows. I noted the light over her eyelid on the shadow side.

Keep the Division of Light and Shadow

At this stage, as new colors are introduced, you risk losing the value relationships between the light side of the face and the shadow side. I see this happen to my students over and over again. A painting will start off looking like the model is in direct lamp light and end up looking like the light is coming from every direction. The painting no longer has a dramatic division of light and shadow. This happens because the artist, without thinking, uses colors in the dark shapes that were intended for the light shapes, and vice versa. Try to avoid carrying the light sticks into the darks and the dark sticks into the lights. If you see a dark color in the shadows that looks like the same hue as a color you used in the lights, look for a darker shade of that color.

If I lose the big light/shadow relationships between shapes, I correct the problem by backing up to an earlier stage and loosely reblocking in the large lost shapes. In the painting *Emily* that would mean going back to step two and reblocking in the simple light

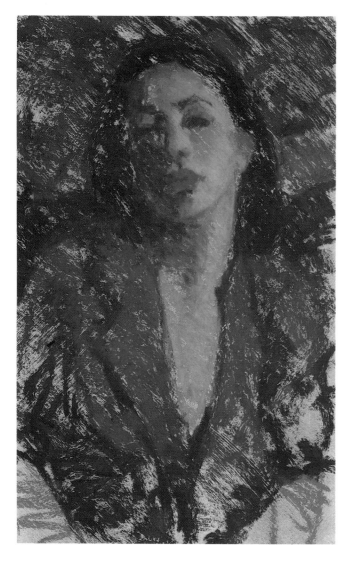

▲ I divided the background into smaller shapes using colors I thought would be in the finished picture so that I could judge the colors of Emily's face accurately. I continued to divide up the large shapes into intermediate shapes. I changed the blouse color, blocking in the light shapes in the blouse with violet-red. I added some of this same red to the mouth so the two shapes would be related by color. As I work, I check proportions periodically. I checked them in the beginning, and again at this stage, about halfway through.

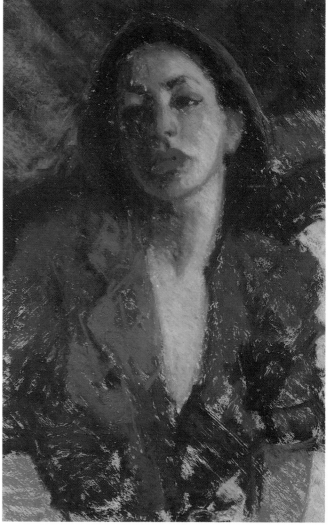

▲ At this point I continued to work on the shadow side of the face, keeping the shapes about intermediate sized to give an impressionistic feel to the painting. Up to this point, I held back on the lighter values in the painting. Now I felt confident of where I wanted to place them. I lightened the light side of the face and the light lapel of the blouse.

and shadow side of the face. *Don't try to solve this problem by painting details.* Fortunately, I didn't lose those value relationships, so I went on.

Block In the Background

Blocking in the background early is an important step. A common mistake students make is that of putting off painting the background. Colors are judged in relationship to the colors that are next to them. The colors used in Emily's face will be judged in relationship to the color around her face, that of her hair and background and, to a lesser degree, of her blouse. Since I planned to change the background color, adding blue in places and red in other places, it was important to make those changes before I tried to do any more work on her face. With the background in I can make good color decisions about her face and other parts of the painting.

Decide How to Finish

If the shapes are left large or intermediate in size, the painting will be impressionistic in style. If they are very small, it will be realistic. I like the impressionistic feeling of the painting *Emily*. At this point, my instincts were to finish it impressionistically. That means I wouldn't divide it into shapes much smaller than the smallest shapes I had already used. Instead, I tried to make sure each shape was the correct color, value and contour.

In this last stage I made sure each shape was the color and value I wanted it to be. As I went over the painting, I corrected the edges between shapes, making some edges soft where they should be soft and keeping others hard where they should be hard. As I worked on the shapes and edges, I eliminated the spots of board showing through, especially in the dark areas of the painting.

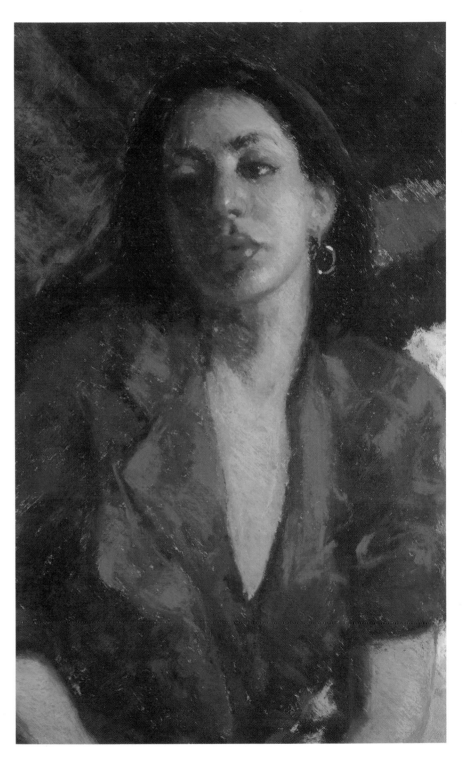

In *Emily* I used the shapes around her eye as the key shapes (see Chapter Six for an explanation of key shapes). I adjusted the other shapes in the painting so their values were correct in relationship to those values around her eye.

▲ **"Emily"** 22″ × 14″
I held off the lightest values until the end of the painting process when I could place them cleanly and precisely.

Painting Facial Features Realistically

Paint the eye by blocking in the shadows over both eyes. When the light is from above, as it nearly always is, there is a shadow under the brow ridge that covers the eyes. The shadows over the two eyes are often continuous and connected with each other by a small shadow over the bridge of the nose. Within this shadow shape are the dark shape of the iris, the shadow of the upper lid across the eye, and the smaller shadows around the eye. Paint these as a single dark shape.

The upper lid sticks out and often catches and reflects light that got past the brow ridge. Painting this small light shape as it exists is the next logical step. The last step is to paint in the "white of the eye" and any light highlights in the eye. However, *the white of the eye is almost never white*. Depending on the lighting conditions, it is often darker than the lightest values on the skin. If the light is at the right angle in front of the subject, there may be highlights. Paint them only if they are really there. I have illustrated the

▲ Block in the shadow over the eye.

▲ Paint the shadow within the shadow as a single dark shape.

▲ Paint the light on the lid and any highlights you see.

▲ Block in a modified pyramid.

▲ Separate the light side of the nose from the bridge.

▲ Add the halftones and nostrils if you must, but never in black.

method used to paint these features the way I would develop them in a painting. Become familiar with the structures and learn to look for them.

Paint the nose by blocking in the shadows to the side and under the nose first. Visualize the nose as a modified pyramid in shape. It has three sides, one of which is much smaller

▲ Paint a continuous shadow including the whole mouth and the shadow below the mouth.

▲ Paint the value of the upper lip and shadow.

▲ Lighten the lighted part of the lower lip and soften the edges.

than the others. The two long sides are cut off where they meet to form the bridge of the nose. When there is a direct source of light from above and in front, one of the long sides is almost always in shadow, and there is almost always a shadow cast by the nose that falls across the upper mouth. This latter shadow is very important because it sculpts the shape of the upper mouth. Next, separate the light side of the nose from the bridge of the nose. Even if they appear similar in value, assume that one of these two shapes is lighter than the other. The last step is to block in the halftones, those middle values that separate the bridge from the shadow side and separate the tip of the nose from the underside. Don't paint nostrils. If you do paint them in, let it be a last step, and never use black.

Paint the mouth by blocking in the whole shape of the upper lip and the shadow below the lower lip. Paint them continuous with the shadow on the side of the face and the shadow cast by the nose. Use the color you are going to use on the mouth and fill in the whole shape of the mouth, upper and lower lip. Make it larger than the mouth really is, so that you will have to use the shape above the mouth to trim it down to size. When the light is from above, the lower lip is lighter in value than the upper lip. Paint in the value of the upper lip. As a final step soften the outer edges of the lower lip so that the value and color of the light skin enter this shape. Right above the upper lip is a little flat plane that catches light.

Working from big to small shapes lets me observe the painting as it progresses from loose to tight, from abstract to representational. Seeing paintings go from loose to tight, over and over again, has sharpened my sense of where to stop with each painting. I have learned that the stopping point is not always at the same place for every painting; nor is it always at the same place within every part of a painting. The background shapes might be left looser than those in the foreground, or the mouth and nose might be tighter than the rest of the face. I can selectively develop different parts of the piece to draw attention to them. I can choose to finish the painting at whatever stage pleases me.

F O U R

Working from Shape to Shape

A shape-to-shape painting is organized by adding one little shape at a time. For this reason I also call it "puzzle painting." There are two advantages to this approach. First, puzzle painting is the best way to build accurate value relationships, because the method mimics the procedure described in Chapter Three for building accurate values. I find practice with this method sharpens my ability to see values. Second, puzzle painting helps you identify the most important elements in the composition, because you are drawn to these as the best places to begin.

▲ **"Taos Barn"** 10″ × 12″

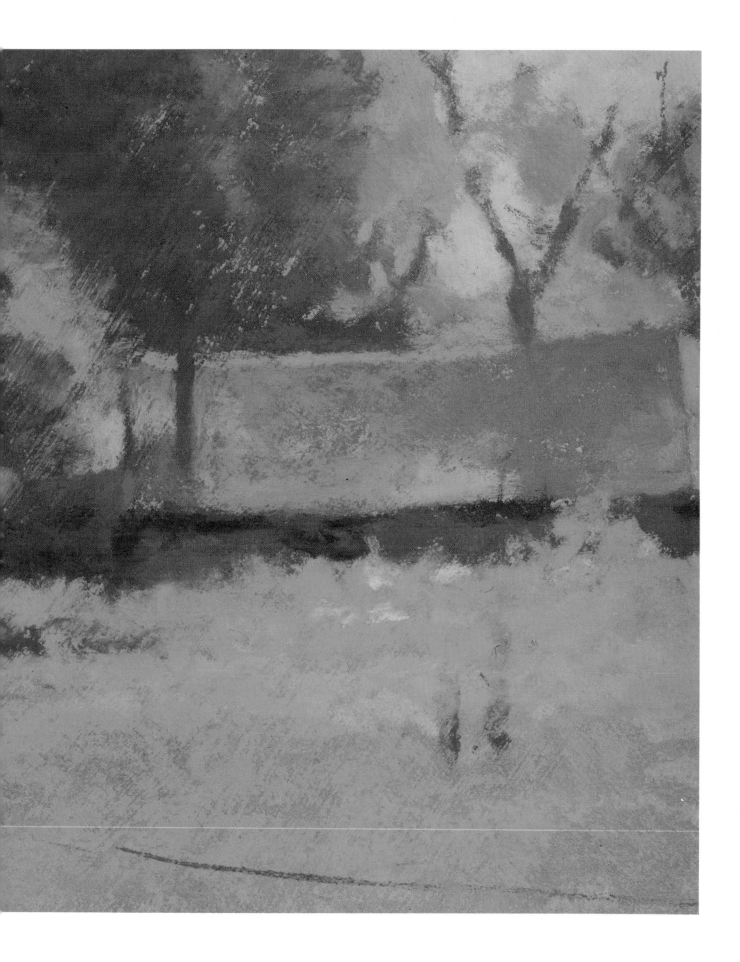

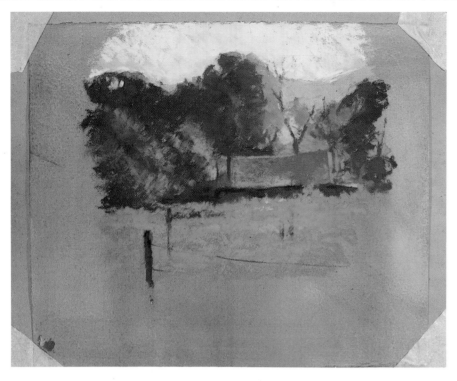

▲ I began this painting with the assumption that I would have to crop it when it was finished. You can see that, based upon what interested me in the painting, I started too high. In puzzle painting the first small shapes are often painted in the wrong place. That is why I routinely work on a larger piece of paper than I expect to need.

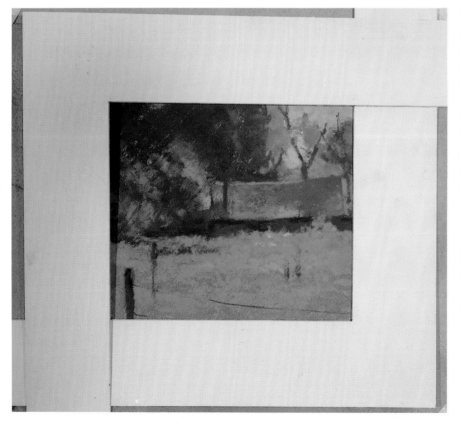

▲ **"Taos Barn"** 10″ × 12″
When I had finished, I composed the painting by using two L-shaped pieces of mat board to make an adjustable rectangle. Before I cropped, I added an additional half-inch border to allow for the eventual overlap of the mat.

One disadvantage to puzzle painting is that it's not good for arriving at composition. Composition is dependent upon large shapes, and puzzle painting directs your attention to the small shapes. The procedure can also get you into trouble with color, because it encourages you to use too many colors. There is a temptation to grab a new color for every new shape in the painting.

To overcome the difficulty of establishing composition, many people combine puzzle painting with drawing or working from large to small shapes. They establish the composition first by one of these methods, then switch to puzzle painting. I prefer to solve the problem of composition by cropping after the painting is finished. In *Taos Barn*, I worked on a piece of paper larger than I anticipated needing. When I finished, I composed the painting by using two L-shaped pieces of mat board to make an adjustable rectangle. Before I cropped I added an additional half-inch border to allow for the eventual overlap of the mat.

To overcome the temptation to use too many colors I keep a constant eye on how many colors I am using. As I selected pastels for *Taos Barn* I separated them from the rest, placing them on my easel. If the pile of pastels on the easel had gotten too big, I would have known I was in trouble. In addition, I followed the procedure of adding to each new shape a little color from one of the shapes next to it. This practice ensures that, as each shape is added, it is brought into harmony with the others. Finally, I try to use at least one stick of color that is the color of the paper. This allows me to integrate the color of the painting with that of the paper so that if paper shows through in the finished piece it all looks like it goes together.

Demonstration

It is important to start with a shape that interests you. In *Pam at Rest*, I began with her eye. I often begin with eyes because they are one of the most expressive elements. You can begin with any shape, however. I recommend you start with a shape that is easily identified, such as an eye, nose, or mouth. If you start on a nondescript shape like a shoulder or neck, you could work a long time and not feel you are making any progress.

I *always build onto an existing shape.* I don't jump from one area in the painting to another. It is like putting together a jigsaw puzzle, as you find each piece you glue it down. You would never risk starting a new part of the puzzle somewhere else in the hope that the two parts would properly come together. Similarly, when you are puzzle painting, don't jump over and start working somewhere else. Always work on shapes next to existing shapes.

A shape-to-shape painting seems to grow naturally as your instincts tell you which little shape to add next. As it grows it is a constantly changing vignette, because part of the board is visible right up to the last moment.

If I make mistakes in color or value or proportion—and I made several of them on this piece—I go back and correct them when I see them. If you correct one shape, you may have to reexamine the other shapes to make sure the value relationships are still correct.

Try to *establish a common color* in each of the large areas of the painting. In *Pam at Rest* I consistently used a light value of green intermixed with all the different shapes in the flesh. In this way a little green got mixed with each of the other colors in the flesh. All the colors in the flesh became related by virtue of sharing that green.

▲ I began the painting *Pam at Rest* by blocking in one small shape on the painting that corresponded to a shape just above her eye. As I did this I tried to make it the correct hue, intensity and value. Then I picked out a second shape on the subject, one next to the first. I blocked this one in the same manner, making sure it was also correct in color and value. In this first step of the painting you can see that I have already blocked in several shapes around her eye.

▲ I followed the eye down into the nose and the nose into the mouth. I made the side of the face flow into the hair and the hair into the background. I tried to make each shape the correct hue, intensity and value as I went. I kept the edges between shapes soft where they were soft and hard where they were hard on the model.

▶ I let my instincts guide me from one shape to another. I try not to be trapped inside of the figure but to look for places where shapes in the figure lead to shapes in the background. If they interest me I follow them, like hopping from one square to another in hopscotch.

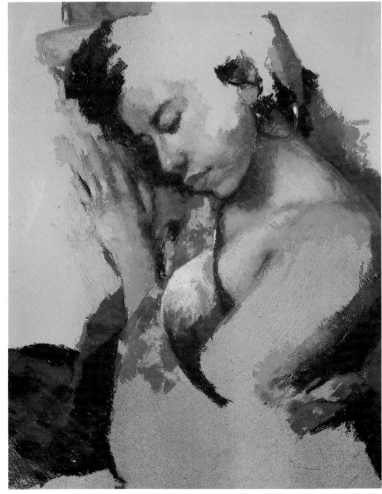

▶ I decided at this point that some of the values in the face were not accurate. I went back in and reworked a few of the shapes. Whenever you spot a mistake, don't hesitate to go back and correct it. I also changed the shape of her upper lip. For me the mouth and eyes are the two most expressive elements. Even though this is not intended to be a portrait, getting the mouth right is important to getting the feeling of the painting right.

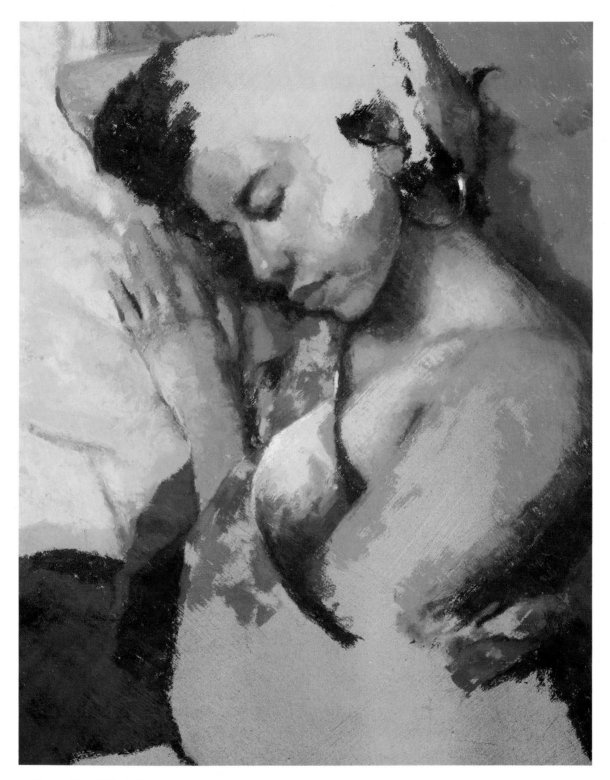

▲ **"Pam at Rest"** 22″ × 20″
This is the first stage at which I start to feel good about the painting. Here is where I begin to ask myself how much further will I develop it. Will I completely cover the board, or will I leave part of it open like a vignette? I decided to fill in the large background shapes on the right and left sides. I noticed the little touch of red next to her palm. It looked good, so I looked for other places in the painting where I could use the same color on an edge. I added some more red next to her finger and upper elbow.

Combining Painting and Drawing Methods

In my judgment, the ultimate technical skill for the artist is the ability to move freely between drawing and painting methods. I want to be so at ease with each of the fundamental methods of drawing and painting that I can alter my approach in response to whatever I am painting. To be able to do this I not only need to know the methods, I need to understand the advantages and shortcomings of each. With that knowledge, I can alter my approach to compensate for shortcomings as I switch from one method to another.

Most of the examples in this chapter are vignettes, or at the very least they have a little paper showing through. I selected these examples because the different techniques show up a little clearer in them. I don't want to give the impression, however, that combining techniques is synonymous with creating vignettes.

▲ **"Ravenna"** 15″ × 13″
Collection of Mr. and Mrs. M. Moxley

▲ **"Ah-So"** 21″ × 15½″
Collection of Kent and Veerle Ullberg
This painting is a vignette done on German etching paper with acrylic washes. My purpose in this study was to capture Kenny's expression, so I quickly painted in the face using the "large to small shape" technique. I then indicated his shoulders and lapels using a loose drawing technique. It is usually advisable to bring all the parts of a painting to completion at the same time. However, in this case I finished his facial expression first, because if that didn't work, the painting would have failed anyway.

Combining Drawing and Working from Large to Small Shapes

In *Ah-So* I painted the face first because I was totally preoccupied with Kenny's expression. I added the drawing later. Many expressions like smiles are fleeting. One advantage to working from large to small as a first step is that I could block in Kenny's expression quickly. After I had the expression going the way I wanted it to, I drew the shape of the hat, shoulder and neckline with a dark pastel. As I drew I varied the thickness of the lines to make them more aesthetically interesting. This was the first of several paintings I did of Kenny. I did it as a study for a later work, and because I knew it was a study, I felt freer to experiment.

One traditional way people are taught to paint is to draw out the big shapes and then block them in. This is a variation on the theme of combining drawing and "painting large to small shapes."

Combining Drawing and Working from Shape to Shape

In *Anndra in Purple* I built up Anndra's face using puzzle painting. Later, I alternated between drawing and puzzle painting as I developed the background, her hat and her dress. The texture in the hat and dress is the accidental surface of the acrylic-covered Masonite board showing through. The width of the lines drawn around the hat and dress was too thick; they looked like snakes surrounding everything. The lines also didn't look like they went with the rest of the painting. To make the lines more interesting and less dominant, I decided to work over them. I painted over them with short strokes of color, making them

very thin in some places and leaving them thick in other places. In order to integrate the technique, I imitated the pattern and texture of the colors on the acrylic surface as I painted these short strokes of pastel.

In a variation on this theme, you can do a detail drawing first, then develop a puzzle painting using the drawing as a guide. This is another traditional way people are taught to paint.

I blocked in *Raggedy Man* using what I refer to as the *spider web method*. In this method I build a network of lines like a web, and as I draw, I pause periodically to hang large shapes from the lines. First I drew the line representing the underside of his hood; then I hung the shape of his face from that line. Next I drew the lines across the top of the hood and over his shoulders. I hung the red shape of his vest from the shoulder lines. The spider web approach is an easy and straightforward way to work with line and shape right from the beginning.

When techniques are combined, it is important that the total effect be balanced and unlabored looking. Each line and shape should look purposeful. There is a difference between dull and dirty color. Dirty colors make a painting look overworked. Colors can be dull, as in *Raggedy Man*, but if they look dirty, then they are the wrong dull colors. If there are no transitions between techniques, then each technique must be balanced with itself. This means that if there is line on one side of the painting, as there is in *Raggedy Man*, then there needs to be line on the other side to balance it out. If there is painting on one side, then there needs to be painting on the other side. It is not the method of application so much as it is the texture that must be balanced.

▲ **"Anndra in Purple"** 12″ × 10½″
Collection of Rebecca S. Cohen
In most of *Anndra*, I alternated between drawing and puzzle painting. It was done on a Masonite board prepared with a purple accidental surface. I drew in the hat and dress with line but blocked in her face and the background.

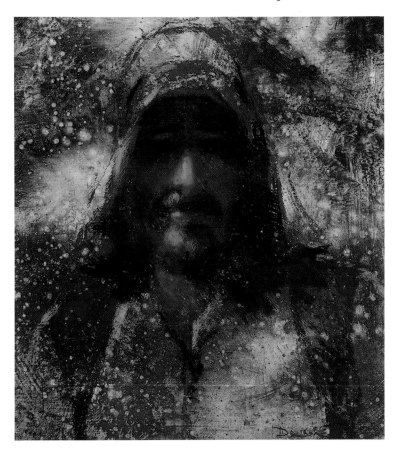

▲ **"Raggedy Man"** 17½″ × 16″
In *Raggedy Man* I used what I call the "spider web approach." I built a network of lines and periodically hung a shape from one of the lines.

Interpreting Value Effectively

Learning to see and interpret value is *the* most important skill in painting. In principle the procedure is simple. In reality, it requires a lot of practice. Don't get discouraged. It doesn't come naturally to anyone. Learning to be an artist is not so much a matter of training your hand as it is a matter of training your eye.

▶ **"Billie"** 19″×15″
Valhalla Gallery collection, Wichita, Kansas

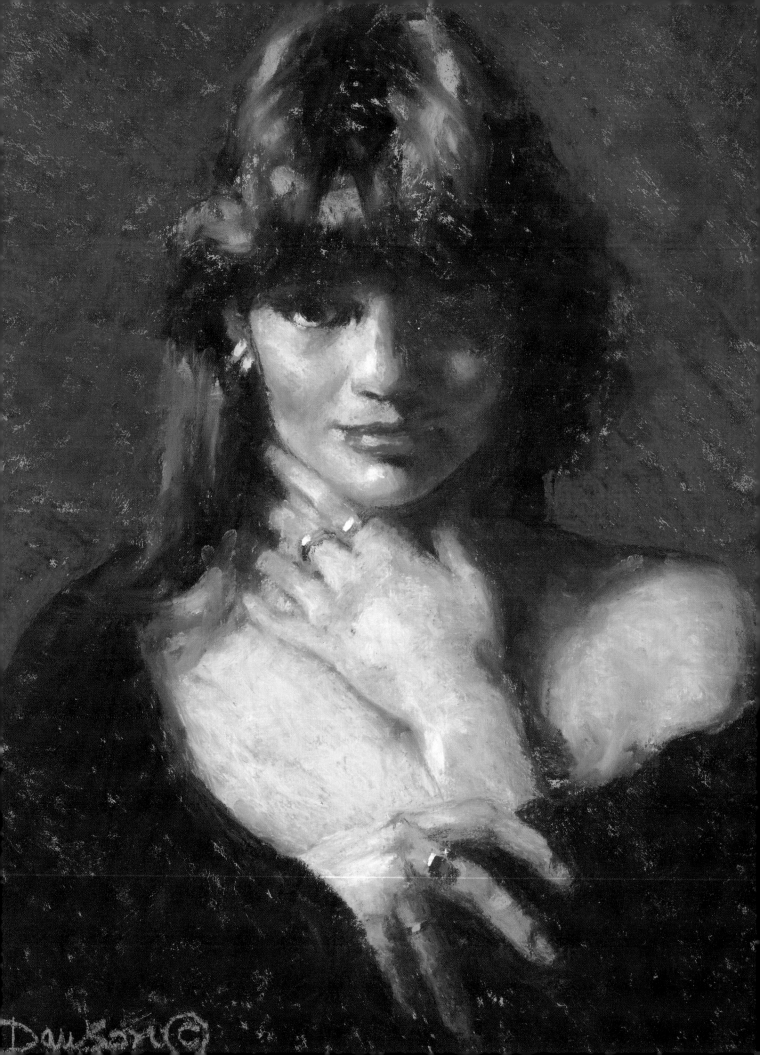

▲ The first thing I do is pick out a shape on the subject which I imitate on the painting. Everything else will be compared to the value of this shape. Therefore I call it the key shape.

▲ Here I added a second and third shape duplicating the contrast I saw between the key shape on the subject and adjoining shapes. (The subject in this case is a photograph of myself. This is as close as I have come to doing a self-portrait.)

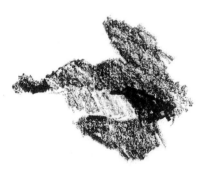

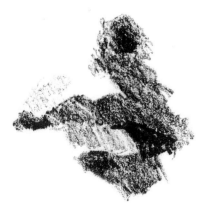

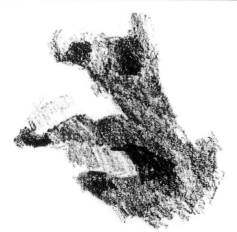

▲ These steps show a continuation of the process of adding shapes and comparing them to the key shape.

Interpreting value is the art of making comparisons. There are three types of comparisons. The first is to compare one shape on the model to one shape on the painting. If the value of the shape in the painting is not the same as the value of the shape on the model, correct it. I call this first step establishing the *key shape*. It is the key shape because the values of all the shapes in the painting are based upon it. Therefore, it is the key to all value relationships.

An interesting side note: It is not necessary that the key shape be correct! It is only necessary that you treat it as if it were correct. If the key shape is darker than the shape on the model, the painting will be lighter. The important thing is that the value relationships, that is the contrast between values, are the same in the painting as the contrast between values on the model. If these relationships are correct, then the painting will accurately reflect your visual experience.

The second type of comparison is to compare the value of two shapes on the model, a shape you choose and one of the shapes next to it. Squint while you are doing this. Squinting turns off the color sensitive cells in your eyes, so you are less distracted by color. While squinting, compare the two shapes. Ask yourself, Are the two shapes the same in value? Are they very similar in value or are they quite different? To answer this question, look at the edges between the shapes. If the values are the same, the edges between the two shapes will disappear when you squint. If the values are only slightly different, the edges between them will be soft. If the values are very different,

the edges between the shapes will be hard and distinct.

The third type of comparison is to compare the two corresponding shapes on the painting, the key shape and the shape next to it. While squinting at the two shapes in the painting, ask yourself, Is the contrast in value between these two shapes the same as the contrast in value between the two shapes on the model? If not, correct the contrast in the painting. Don't change the key shape. Remember, it is the key to all the others. As you move on to other shapes on the model, you repeat this process over and over again until all the value relationships are correct.

If you don't identify a key shape, each segment of the painting will tend to develop its own set of value relationships independent of the other segments. You will instinctively compare the shapes in the face to each other, the shapes in the blouse to each other, the shapes in the background to each other, and so forth. Without a key shape, the different sections of the painting may work, but the painting as a whole won't work. *The biggest mistake you can make with value is failing to identify a key shape.*

The cards shown here are a couple of simple devices you can use to perfect your ability to see value. The first card has a ¼-inch wide slit in it. The second is similar except that it uses a pair of ¼-inch holes. You can line up the cards so that the values you wish to compare are both visible in the slit or in the two holes. The cards allow you to compare values without the distraction of all the surrounding objects.

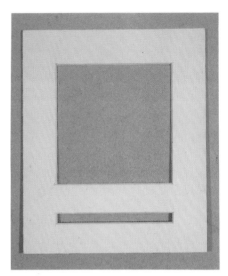

▲ The square opening in this card, which is 3½ × 3½ inches, serves as a viewfinder for composing paintings. The ¼-inch wide slit is useful for comparing values. To use the slit, just line it up so the two shapes you want to compare are both visible through it. The advantage of the slit is that it eliminates distraction by recognizable objects.

▲ The purpose of this card is the same. The only difference is that holes are used instead of a slit for comparing values. I used a leather punch to make the holes. To use it, line up one hole over each of the shapes you want to compare.

Composing Better Paintings

There are many things to think about when painting. The problems can be overwhelming. Sometimes when I paint, I know exactly what I am going to do. At other times I am uncertain and don't know where to begin. If I can identify the problem causing my hesitation, I can usually work through that problem with a preliminary sketch. These small preliminary studies are called thumbnails.

If I can't visualize the best composition for a painting, I do a number of small studies to determine which arrangement of shapes is the most pleasing. I keep the studies small so they won't take much time or cost too much in materials. If I am confident about the composition but am not certain which colors to use, a small color study will usually provide the solution. If the first study doesn't work, it doesn't take long to do a second or third. I do as many as it takes to satisfy myself that I have discovered a good solution.

▶ **"Waxman's"** 15½″ × 18″
Collection of R. Leher

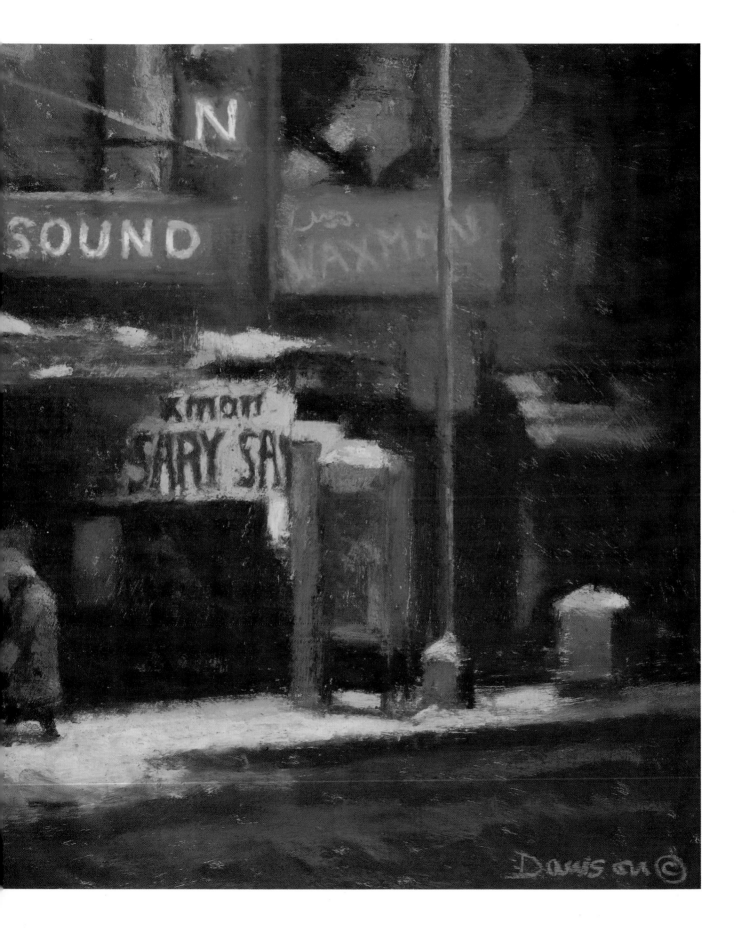

Using Thumbnails

The best way to use a thumbnail is to have a clear idea of the problem or problems you are trying to solve. The best type of thumbnail is the one in which you are just trying to solve one problem. Two of the most common types of problems that can be solved with thumbnails are composition and color. I routinely use thumbnails to determine the composition or the arrangement of colors I will use.

Solving a Problem of Procedure

In *Chaska Sunset* I wasn't trying to solve composition or color problems. I was trying to solve a problem of procedure. I couldn't decide whether to paint the colors I saw directly, or to block in the big shapes with other colors that I would later cover up. I used the latter approach in *Study for Chaska Sunset*. I blocked in the sky and ground with colors I anticipated covering. The thumbnail was pleasing. Although it didn't tell me what the final painting would look like, it told me the colors I chose would be harmonious in the underpainting. That was what I wanted to know. I decided to copy the procedure with *Chaska Sunset*. With the thumbnail as a guide I started the big painting. I blocked the big painting in and took it as far as the thumbnail, then I put the thumbnail aside. I wanted to finish the big piece without being further influenced by the thumbnail.

Solving a Composition Problem

If the purpose of the thumbnail is to solve a composition problem, it is important that the thumbnail have the same proportions height to width as the proportions of the larger painting. Over and over again I see students trying to make compositions done on a board with one set of proportions work on a larger board with a different set of proportions.

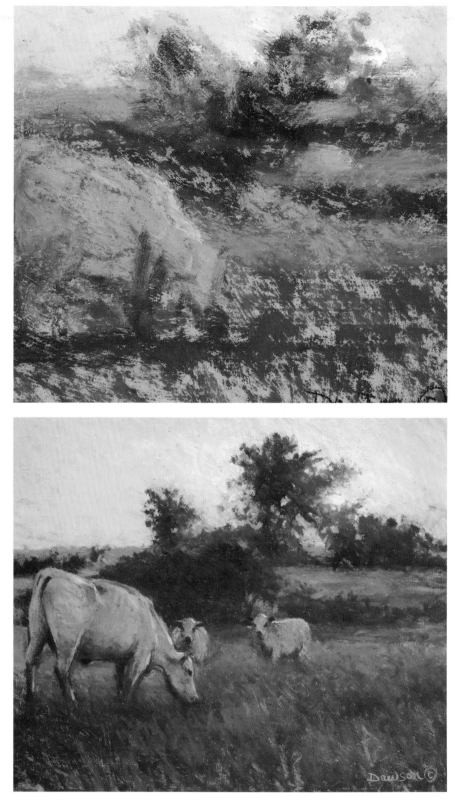

▲ (Top) **"Study for Chaska Sunset"** 7″ × 8″
Collection of Bonnie Macdonald
I did this piece to determine which colors I would use to initially block in *Chaska Sunset*. When I felt I had worked out that step I stopped on the thumbnail. This small painting has a spontaneity and directness not found in the larger piece. The thickness of the pastel and small size of the board prevented me from becoming preoccupied with detail.

▲ (Above) **"Chaska Sunset"** 28″ × 33″
Collection of Mr. and Mrs. Robert M. Zinke
I began this painting by blocking in the larger shapes with the sequence of colors I used in the thumbnail. I then worked over these colors, bringing the painting to its final solution.

◄ **"Study for Boulder Ridge"** 15″ × 15″
Collection of SAKS Galleries
I toned the board for this painting with alizarin crimson. The effect was marvelous in the thumbnail. When I tried to carry it over into the larger painting it failed. One reason has to do with what is called field size. The small spots of red in the thumbnail were exciting, brilliant. In the large painting they became overpowering.

◄ **"Boulder Ridge"** 38″ × 38″
As I worked on this larger painting I found I couldn't leave open spots of red board as I had in the thumbnail, and the darks seemed washed out and dirty. When a painting seems lost, it's a good time for bold experiments. In a desperate attempt to find a solution to the shadow colors, I took a wet brush and painted into the shadows. The results were immediately richer and deeper. This was the first time I ever painted into a pastel with water.

▶ **"Sherry in Pink"** 11″ × 10″
Private collection
Besides resolving some of the color problems, I used this study to familiarize myself with Sherry's features. Although this wasn't a portrait, I often use this technique in portrait painting. I will do a quick thumbnail or two, like a musician practicing his scales. Then I can take on the fine painting with a greater sense of familiarity with the colors to be used in the flesh tones as well as the proportions and character of the features.

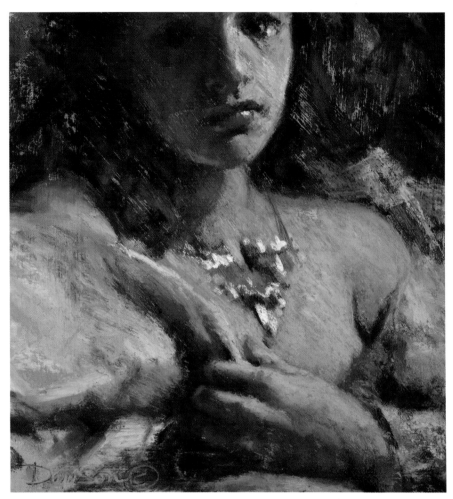

If your only concern is composition, the thumbnails can be done in any medium, on any surface. The simplest approach is to use a black-and-white medium. The advantage is that it eliminates the distraction of color. I frequently rely on pencil thumbnails in preparation for on-the-spot landscapes. Besides eliminating the confusion of color, black and white studies are faster. They only take a minute or two, and I can get started on the larger painting before the lighting conditions change, an important consideration when painting outside. *Boulder Ridge* was a studio painting, so time was not a concern. I did the thumbnail, *Study for Boulder Ridge*, in color because I anticipated wanting to finish it.

I don't finish thumbnails until the large painting is done. It is important

to get on with the large piece while the excitement is still there.

Solving a Color Problem

The simplest type of color thumbnail is a small, abstract one. The color thumbnails should be done with the same medium on the same colored paper or board as you intend to use for the large painting. It is also important if you build up layers of color, as I do, to use the same layers of color as you intend for the final painting. Make sure the colors touch, that they are not separated by open areas of board. You can't judge how one color works with another unless they are touching. Include places where the colors overlap and mix together. In this way you can determine if any of the combinations

is going to give you mud. An abstract thumbnail is the simplest way to evaluate color relationships without the distractions of form and detail.

Another way to eliminate the distraction of form and detail is to use a different composition in the thumbnail. If I am not searching for a compositional solution, if I am just trying to solve a color problem, I will often vary the composition in the thumbnail. It keeps the thumbnail interesting. I used this approach in *Sherry in Pink*. This painting was the thumbnail done for the painting *Sherry*. I knew the smaller painting would not solve all the color relationships in the larger painting because I had Sherry wear a different-colored dress for the larger painting. I only wanted to find color solutions for Sherry's skin tones, her

hair and the background that would work in the larger piece. I didn't want the smaller painting to be just a miniature of the larger one. I wanted to use a composition suited to the smaller board because I hoped to finish the thumbnail later.

Solving Composition and Color at the Same Time

I often use thumbnails to solve problems of composition and color at the same time. To do this it is necessary to duplicate in the thumbnail both the proportions of the board and the major color relationships and procedures. When I was satisfied with the thumbnail *Study for Denver Drug*, I prepared a board for the larger painting with the same proportions height to width and toned with the same color.

As I worked on the larger version I used the same palette and duplicated the layering and juxtapositioning of color used in the thumbnail. I reminded myself that the colors I found pleasing in the thumbnail were not just a product of the surface color but of the colors underneath as well. They were also a product of the placement of colors, of which color was next to which. In *Denver Drug* I carefully repeated the layering and positioning of the colors used in the thumbnail.

The thumbnail often includes many little color experiments. Some of them work and some don't. I try to identify the ones that work while at the same time eliminating those that don't. I determined that the blue used in the shadow on the snow in front of the door in *Study for Denver Drug* didn't work very well. In *Denver Drug* I moved the color over to the half tone on the left side of the painting. Apart from that I was fairly true to the original thumbnail.

Why paint thumbnails? Besides the reasons I have already alluded to at the beginning of the chapter, it is a practical and economical way to conserve time and solve problems on a smaller scale. It is also an exceptional learning experience. Thumbnails like *Study for Denver Drug* differ in exciting ways from large paintings. Because they are done quickly, the lines and strokes in them are more immediate and energetic. Because thumbnails are seen as less important than the larger pieces, even disposable, they tend to be more experimental and

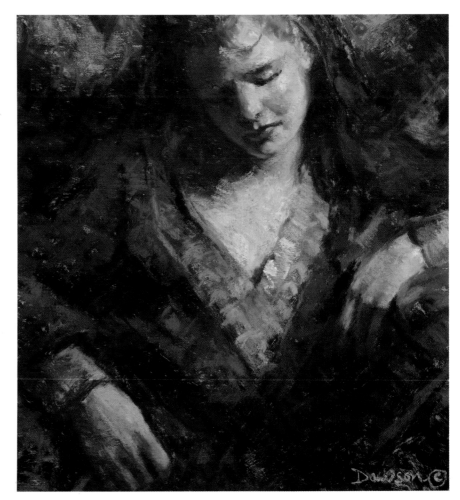

▶ **"Sherry"** 20″×18″
Collection of Vincent and Shirley Martino
When you discover something in the thumbnail, you don't have to live with it as though it were written in stone. It is a stepping-off point for further experimentation. Sherry is a redhead and has very translucent skin. In the thumbnail I played with a combination of colors for the skin tone that pleased me. Still, I altered that combination a little in this painting by using a little more blue, trying to improve on what I had created in the first painting.

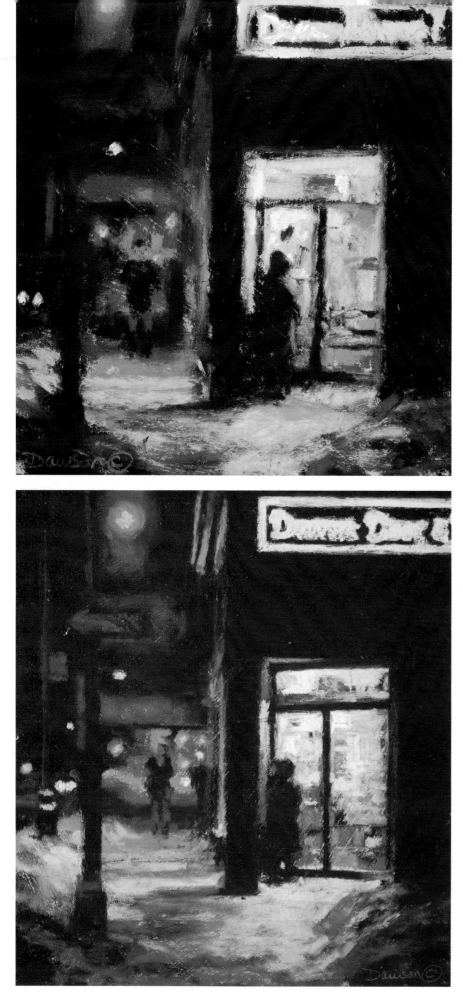

playful in content. Because the thumbnail is small and the strokes of pastel are larger proportionately, the thumbnail is more impressionistic in style. These qualities are worth understanding. I continue to look for ways to apply what I have learned from thumbnails to my larger paintings.

A final note: Thumbnails are almost too effective at solving visual problems. The ultimate joy in painting is the activity of making discoveries and finding solutions. Each painting is like a puzzle ready to be solved. I believe the most exciting paintings are ones that contain evidence of this creative struggle. When a painting lacks this evidence, it looks slick and lifeless no matter how perfect it is in every other way. I try to take some risks in every painting. I try in every painting to hold on to a few problems that I have still to solve. I use thumbnails, but I use them sparingly. I don't try to solve every painting with them. There is no joy and very little art in a puzzle you have already solved and are simply enlarging.

▲ **"Study of Denver Drug"** 9″ × 10″
Collection of Calvin and Barbara Johnson
This painting has a special quality probably not apparent in reproduction because the two paintings appear similar in size. I often think of the thumbnail as the little jewel.

◄ **"Denver Drug"** 19″ × 17″
Collection of Deloitte-Haskins Firm, Denver, Colorado
In *Study for Denver Drug* I used a light yellow over the top of a light pink for the lightest values in the window. I was careful to repeat this same layering of color in the larger version. When I was less mature as an artist, I often mistakenly thought the solution in the thumbnail was just the color I had used on top.

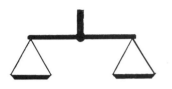

▲ A steelyard measuring device.

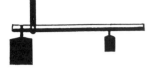

▲ A balance scale.

Sixteen Compositional Models

The variety of compositions is endless. Yet each composition is a variation on one of just a few basic patterns. This section describes sixteen of these patterns or compositional models. Each pattern is identified by a name that symbolizes the attributes of that pattern. For example, one is called the *S* model. It describes all those compositions in which an S-shaped curve is the dominant element. Another is called the *Steelyard* model. This is an archaic term for a beam, balanced on a fulcrum, with weights of different measure on each end. *Steelyard* compositions are those in which a large weight on one side is balanced by a smaller weight on the opposite side.

The study of compositional models is not a substitute for learning how to use line, shape, color, and so on to create balance, unity, and a center of interest in a painting. The primary purpose for compositional models is to intensify our awareness of alternative

▲ **Steelyard.** In the Steelyard model, the center of interest is usually located close to the largest shape, in the position represented by the fulcrum if this were a balance.

▲ **Suspended Steelyard.** This is really an upside down Steelyard. Like the Steelyard model, the center of interest here is located near the largest shape.

▲ **"L" Model.** This is really a variation of the Steelyard model in which the smaller of the two shapes is outside the border of the composition. The center of interest is usually on or near the vertical line. A variation on this idea is the *Inverted L*. It is the same idea, just upside down.

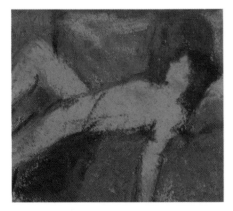

▲ **"H" Model.** This might be visualized as a combination of the Steelyard and Suspended Steelyard. The center of interest is often on the horizontal line of the capital *H*. A variation on this theme is the *Roman Numeral II* model in which the cross piece is at the top and the bottom instead of in the middle.

▲ **Balance Scale.** Imagine the balance scale as portrayed by the scale of justice. This is made up of a middle upper point, where it is held, and two lower baskets.

▲ **Pyramid.** This is a shape or arrangement of shapes that in contour looks like a triangle. Whereas the Balance Scale and Three Spot (see page 51) direct your attention to the points of the triangle by having prominent shapes there, in the pyramid composition you are more aware of the edge of the triangle.

▲ **Silhouette.** In the silhouette model the principal shape is very dark. The center of interest is usually identified by the interesting edge that surrounds the shape. The dark area is not necessarily black; it may be light enough for you to break it down into smaller shapes. Still, the impression should be dark silhouetted against light.

▲ **Circle.** This is an arrangement of shapes that forms a circle. Generally the center of interest is located somewhere on the circle or near its edge.

▲ **Group Mass.** This is a shape or collection of shapes that forms a single dominant mass in the composition. This is probably the model most commonly used in figure painting. Almost every head and shoulder study falls into this category.

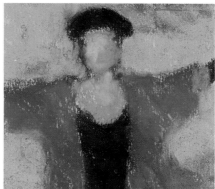

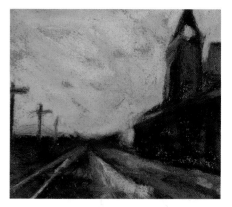

▲ **Tunnel.** What distinguishes the tunnel from the circle composition is that the use of value color and line tends to draw you into the tunnel shape. The center of interest is generally within this shape. In the circle composition, you are not drawn into the circle so much as you are directed around and around the circle.

▲ **Cross.** This composition typically has two lines that intersect. Or it might be thought of as having four lines that converge at one point. The center of interest is usually located toward the intersection of the lines. A variation on this theme might be thought of as the *T* composition. It works equally well. In the *T* composition the two lines meet but don't cross.

▲ **Radiating Line.** This is similar to the Cross composition in that it has a number of lines that converge at one point. Generally the center of interest is near the point of convergence.

▲ **Pattern.** This is a catchall category for compositions that work but don't seem to fit the character of other models. Generally the pattern composition achieves unity by repetition of some basic shapes.

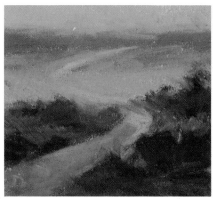

▲ **"S" Model.** This model immediately evokes thoughts of a wandering stream or path. The center of interest is usually on the line or very close to it. This model has long been a favorite of photographers.

▲ **Diagonal Line.** This is a line running diagonally from one upper corner to the opposite lower corner. The center of interest is either on or near the line. An important consideration is that some device is needed at the lower end of the diagonal to prevent the eye from slipping right out of the painting. The simplest device is a small vertical shape. A variation on this theme is the *V* composition, which is like two diagonal compositions tilted toward each other.

▲ **Three Spot.** The difference between the Three Spot and the Balance Scale is that in this compositional model, the three shapes can be located in any position, whereas one spot is always toward the top and middle in the Balance Scale. The center of interest is either one of the three spots or a point within the triangle formed by the three spots.

compositions. Our imaginations are limited, and we are creatures of habit. Having once found an arrangement of shapes that is pleasing, my natural impulse and yours would be to repeat that pattern over and over again. Studying compositional models increases our options by making us more aware of patterns that other artists have found pleasing. I refer to my memory of these when I search the land or city for interesting subject matter. I rely first upon my instincts; secondarily, I look for arrangements of shapes that imitate the patterns of the different models.

Some models are associated more with landscape and some with figure painting or still life. For example, the S and the *Steelyard* are frequently used in landscape. But, there is no rule that says a particular pattern may only be used with a particular subject. One challenge is to find new ways to apply these patterns to subject matter not normally associated with them. This may lead to interesting artistic breakthroughs. Right now, for example, I am currently looking for ways to use the *Circle* and *Tunnel* composition with still life and figure.

I suggest you commit these models to memory. There is no special magic about them. Their sole purpose is to broaden your thinking when it comes to composition. Try to discover new patterns if you can. I added four patterns of my own: the *Inverted L*, the *T*, the *V*, and the *Roman Numeral II*. I described these in the captions as variations on the other sixteen. By discovering a pattern of your own you may open up a fresh new direction for your work.

Solutions to Your Color Problems

A good colorist is not someone who knows the exact solution to every color problem. The only people who do are those who use the same solution for everything. A good colorist is someone who knows how to search for solutions, and that is what this chapter is about, searching for solutions to your color problems.

When I begin a painting I try to establish a set of simple harmonies that will hold everything together as the painting progresses. It is easier to maintain harmony that is already established than to try and rebuild it later. As the painting develops, more and more colors are added and the problem becomes maintaining harmony while searching for exciting combinations of colors. Some of the combinations of colors I try will work and some won't. I try to find the ones that do and eliminate the others. At the end of the painting process, I look over the piece and ask myself, Is it harmonious? If everything else has gone as planned, if it is harmonious, then I am finished. Sometimes it happens that in my search for exciting combinations of colors I have lost harmony. The color is discordant. When this happens there are some remedies I can depend on to reestablish harmony.

▶ **"Fall in the North Woods"** 20″ × 22″
Collection of Mr. and Mrs. R. Liedy

Establishing Color Harmony

How do you establish color harmony at the beginning of the painting? There are several methods, all of which employ one simple idea, the concept of the *common color*. The idea is simple: *Somehow in some way, one color is interwoven with most of the other colors in the painting.* Because one color has been mixed in with most of the other colors, it holds them all together in a harmonious relationship. The color that is interwoven is called the common color. There are a variety of different ways to accomplish the interweaving which include working on a toned surface, underpainting, premixing color, and adding color. The first one I will consider is the use of a simple palette.

Keep Your Palette Simple

Keep your palette simple is the most frequently repeated advice on color. When you keep your palette simple, one color naturally emerges as the common color simply because you used more of it than anything else. A simple palette has three, or at most, four hues of color. If this were a book on oil paint, I would say three or four colors plus black and white. You can't control value with pastel by adding black and white. Mixing black or white with other colors tends to produce mud. So with pastel, a simple palette may include several sticks of different values or shades of each of the three or four colors.

When using the large-to-small shape approach to painting, I keep my palette simple by restricting myself to three sticks of pastel in the initial block-in. This keeps me from getting too many colors going too fast. I try to stay with those three sticks as long as possible before I start adding other sticks of pastel. Remember the negative rule: *If you want to get into trouble just get too many colors going too fast.*

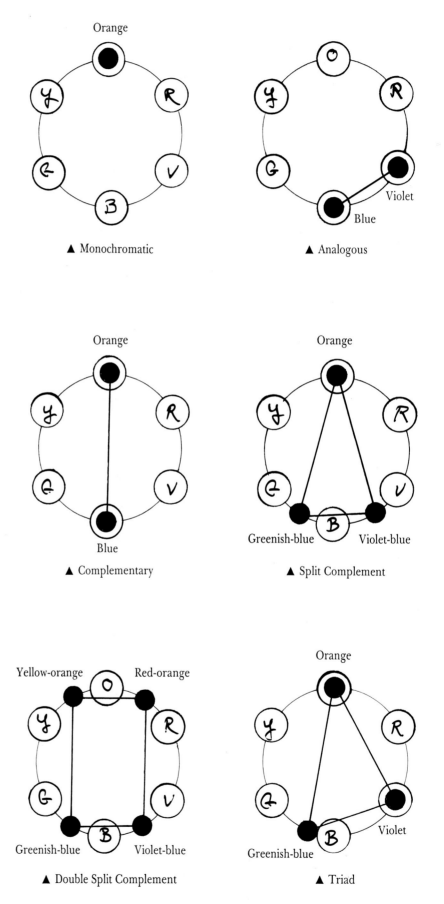

▲ Monochromatic

▲ Analogous

▲ Complementary

▲ Split Complement

▲ Double Split Complement

▲ Triad

As I am working, from time to time I glance down to see how many sticks of pastel I've got going. When the pile gets too big, I know I am in trouble.

Some simple three- or four-color palettes are shown at left: monochromatic, analogous, complementary, split complement, triad, and double split complement. *Monochromatic* refers to a palette that is made up of different values of just one color. An *analogous* palette is one made up of values of two colors that are next to each other on the color wheel, for example blue and green. A *complementary* palette is made up of colors that are opposite each other on the color wheel. There are three sets of complements:

blue/orange, red/green, and yellow/violet. A *split complement* palette is similar to a complementary one except that one of the two complementary colors has been eliminated and the colors to each side of it are used instead. For example, the blue might be eliminated in a blue/orange complementary palette, and a green-blue and violet-blue added. In a *double split complement* both the blue and the orange are eliminated. The palette would consist of a green-blue, a violet-blue, a red-orange, and a yellow-orange. Finally, any three colors on the color wheel can be used and this is referred to as a *triad*.

▲ **"The Temple Fire"** 24″ × 26″
Collection of Kenneth J. Bennett, M.D.
This is a red-orange monochromatic painting. I added a touch of blue in the foreground and a touch of green in the truck for variety and interest. A touch of another color adds variety and interest to monochromatic and analogous paintings. With it or without it, analogous palettes and monochromatic palettes are harmonious. Without it they tend to be rather monotonous.

▶ **"Denver Sunset"** 17″ × 19″
Collection of Lee Ann D. Wadsworth
This painting was done with an analogous palette of blue and green. A little yellow was used in the clouds for variety. If this were purely an analogous painting, it wouldn't include any other colors. Remember that these simple palettes are not written in stone. I could have illustrated these palettes in a pure way, without any other colors added to punch them up. I thought it better to show you examples of how I really use them.

▼ **"Miss Venegas"** 12½″ × 11½″
Collection of Wallace Engstrom
This is a blue/orange complementary palette. These colors are not perfect complements. I call them near complements. When I set up a simple palette I feel free to bend it to the needs of the painting.

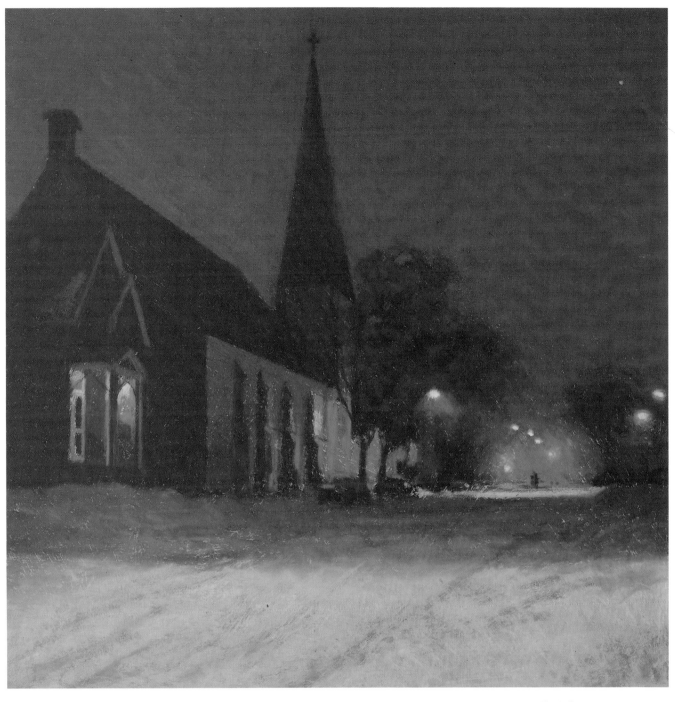

▲ **"Sanctuary"** *33″ × 33″*
Collection of J.T. McGreer
This is a split complement palette of blue-violet on one side and yellow and orange on the other.

A Toned Surface

A toned surface can serve as a common color. If in the finished painting little spots of the paper are allowed to show through, the viewer's eyes mix those little spots of color with the other colors in the painting. The color of the paper becomes the common color.

Underpainting

An underlayer of pastel can be the common color. If an underlayer of color is used, it will be mixed with later layers both optically and physically. It will become the common color. When I work from large to small, I block in each large shape with one of three colors. Each large shape ends up with its own common color. As additional colors are added the common color holds them together in a harmonious relationship.

▲ **"Morning Glow"** 18″ × 19″
Collection of Mark and Beth Shumate
This painting is built upon a double split complement palette of blue, green, red and orange. Instead of using the blue-green and red-orange complements, I split them and used the colors to either side.

▶ **"On the Marsh"** 30″ × 20″
Corporate collection
The pink underpainting becomes the common color in *On the Marsh*, uniting all the different colors.

Dawson ©

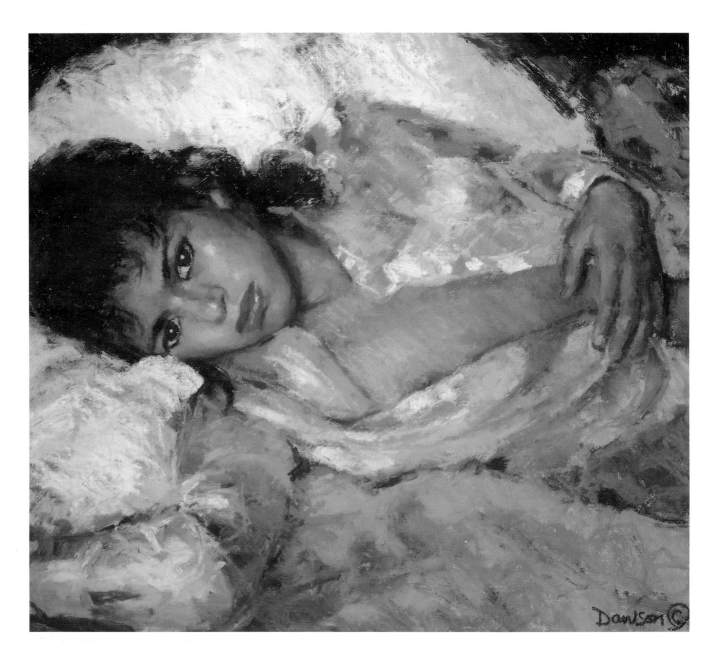

Added Color

When using the shape-to-shape (puzzle) approach, I make sure that I add a little of the adjacent color to each new shape. The color that is carried over serves as a common color. After the painting is completed, one color will emerge as a common color simply because I have used it in more shapes than any other color. If this doesn't occur naturally, then I may have to go back and add a bit of common color to those parts of the painting that seem discordant.

Scumbling

Scumbling is the process of covering a previously painted shape with feathery strokes of one color. If I were using opaque paint instead of pastel, I would use a dry brush to scumble. Scumbling is like placing a thin cheesecloth of color on top of the painting. All the other colors are seen through this layer. Scumbling can be used at any time in the painting process. Since scumbling is a method for adding a common color after the fact, it is one of the few techniques you can use at the end of the painting process to rescue a piece. In the painting *Loris in Pink* I scumbled to unite the flesh tones. The color had been far too broken up, too splotchy. I took one color and scumbled over all the places where flesh was showing. I wasn't trying to eliminate all the other colors, just unite them with a common color.

I don't start paintings with the idea that I will scumble as the final step. Still, when I'm in trouble, I don't hesitate to use this technique to bail myself out.

◄ **"Loris in Pink"** 20″ × 22″
Collection of J.B. Lane
As I worked I imagined that I was applying a layer of skin in the form of the scumble. I used this make-believe skin to cover the muscle, blood, and bone that I imagined were represented by all the colors I had already used.

Searching for Color Solutions

As a painting progresses, I want to add other sticks of colors. At first there is little to guide me but my instincts. Sometimes the first color I try works, but sometimes it doesn't. What do you try next when it doesn't? Finding a color solution seems like trying to find a needle in a haystack—in a field filled with haystacks. A good understanding of color won't lead you directly to the needle, but it may help you limit the number of haystacks you have to search in. For example, when I painted *Head Study of Candace* (see page 63), the cloth behind her head was blue-green, so I tried a blue-green first. It didn't work, so I tried an analogous color. Analogous colors are colors that are next to each other on the color wheel. Here, that would mean blues, blue-greens, and greens. If an analogous color doesn't work, then I consider any of the colors that are on the same temperature side of the color wheel. Blue-green is cool, so I could try any of the other cool colors. If none of these works, then I would conclude that I misjudged the problem. I would then try something radical like complementary or near complementary colors.

Keep Your Experiment Small

As you try one color, then another, keep your experiments small. Too much of a good thing can ruin a painting just like too much frosting on a cake. This is especially true of large, bright, warm shapes such as reds or oranges. It is easier to correct a small experiment that didn't work than a large one. If you overdo it, go back and eliminate some of the color. Brush it out with a bristle brush or work over it. Every now and then I still overdo it. The solution is to recognize the problem so you can correct it.

Use a New Experiment to Correct the Old Ones

Use the experiment that works to eliminate the one that doesn't. In *Head Study of Candace*, I tried a little light blue-green for the light values in the cloth above her shoulder. This didn't work very well, so I tried a second experiment, a light blue. I blocked in a small amount of light blue so it overlapped the blue-green experiment. This allowed me to see what the blue looked like alone, as well as how it looked on top of the blue-green. When analogous colors are used on top of each other, they set up vibrations that are often more exciting than the "correct" color. This was the case here. The second color I tried was actually closer to what I had seen in the cloth. Yet it didn't express that vibrant sense of light I felt. However, the combination of the light blue on top of the light blue-green worked better than either color alone. Exciting color is often a magnification of reality rather than a strict representation of it. Committed to that combination of colors, I blocked in some more light blue-green and then added a layer of light blue on top.

Look for Solutions that Already Exist

Before you try a new experiment look to see if the solution already exists someplace else in the painting. Often the solution does already exist and is just waiting to be noticed. I started to work on the shadows around Candace's eyes. I looked at the other shadows on her face and neck to see if the solution I needed for her eyes already existed. Under her chin, I found a combination of colors I thought would work. There was no point in trying new combinations of colors. I had found my solution. I used the same combination of colors around her eyes.

Look at What's Underneath and What's Next to What

When you discover a color solution, don't assume that it is the surface color alone. Take note of all the color relationships: which color is on top, which is underneath, which color is next to it, and how much of each color is used. In the painting of Candace, I noted that in the shadows under her chin, I had used an Indian red on top of a mars violet. Further, I noted that there was a small area of pink that separated the shadow from the lighter skin tones. When I brought this solution to the eyes, I tried to repeat the layering of color as well as the use of small areas of pink to separate the shadow from the light values.

Look for Other Places to Use the Same Color

When I add a new color, I look for other places in the painting where the same color can be used. When I painted Candace, I saw two different reds. There was the red of her mouth, which was really an orange-red, and the red of the cloth on either side of her face, which was a true red. I used the same red for both of them. By using one red, I was keeping my palette simple and preserving the harmony between the red parts of the painting. I could always change the color of her mouth later if it was absolutely necessary. It was never necessary.

Respect the Identity of Your Painting

At some point every painting takes on its own identity. This identity is inspired by the model or still life or landscape, yet it is different from it. At this time the artist has a choice. He can sacrifice those exciting things that have begun to happen, hoping that by making it more like the subject it will be even more exciting; or the artist can hold on to the exciting things that are happening and solve the painting for what it has become. The painting *Story Time* (page 65) had arrived at that point. It was similar to the subject but was taking on a life of its own. I could keep pushing, trying to make it more like the subject, but that would mean sacrificing some exciting things that were occurring in the painting, or I could solve it for what it was.

The painting was working pretty well but was rather dull. I guessed the problem was that the shadows were the wrong color. I tried a spot of green, thinking I would make the shadows greener if the experiment worked. The results were different than I had expected. That spot of green was an exciting little touch of color. It made the rest of the painting come alive. I could eliminate it—after all, I really didn't see that color on the model—or I could use it because it worked. The painting deserved its own solution. I not only left the green, I used a bit more of it.

Keep Your Color Juicy

Creating exciting color is like making a good vegetable soup. A good homemade vegetable soup usually has juicy hunks of vegetables in a tasty sauce. If you dump the soup into a blender, you reduce the whole thing to mush. All the pieces of vegetables become so small as to no longer be enjoyable. The same principle holds true for painting. If you blend the layers of pastel completely, they look overworked and are no longer exciting. Resist the temptation to blend all of it. Keep the color in tasty chunks, big enough to savor.

Set Small Areas of Intense Color Against Large Areas of Dull Color

The painting with the most exciting color is usually one that has a few bright spots of colors set against large areas of dull color. If you want to make a candle seem bright, light it in a dark room. If you want to make a shape

▶ **"Head Study of Candace"** 12″ × 13″
Private collection
In this painting I selected the darker value of red to block in the cloth next to Candace's head. I used the same color to block in her mouth, even though her lipstick was not that exact color. It would have complicated my palette to add an additional red. When I blocked in the lighter value of red on the cloth I looked for other places this could be used. I saw a pink tone on her cheek that was caused by light bouncing off the cloth onto the side of her face. I used a touch of the same red on her cheek as well as on the neckline even though I didn't really see the pink color on her neck.

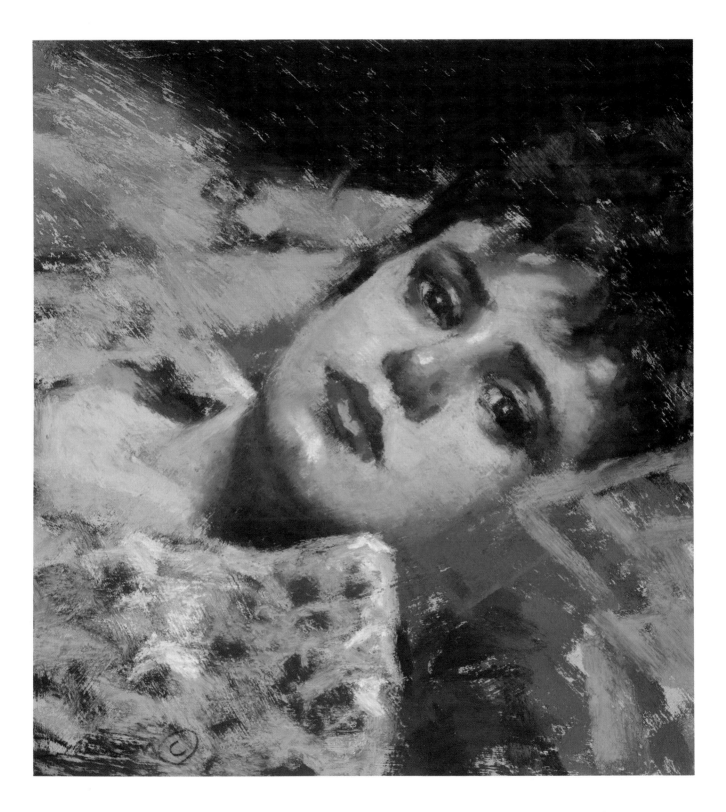

look light, place it next to a large dark shape. If you want to make a color look bright, place it against a large dull shape. If you want to make a color look cool, place it next to a large warm shape. Contrasting the sizes of shapes is the *principle of field size*. Contrasting properties that are opposite, such as bright against dull, is the *principle of simultaneous contrast*. If you doubt that this works, search your art books for the paintings that are the most colorful. Study them. You will find that most of them seem colorful because of just such contrasts.

The ability to mix or select dull colors that will work well with the bright colors in a given painting is a skill that characterizes those who have a mastery of painting. In the painting *Story Time*, there is very little intense color. The small spots of cool green and violet seem brighter because they are set against dull warm colors.

Rescuing a Painting

Finally, at the end of the painting process, what can be done to rescue a piece that is out of harmony? If a painting lacks harmony, it is usually because of one of three problems. The first problem is that the painting lacks a common color. I have already described one remedy for this problem. A layer of color can be scumbled over parts of the painting to reestablish a common color. The second possible problem is that there are too many colors. The painting is out of control. The solution is to eliminate some of the colors. Look for groups of colors that can be simplified. For example, if there are three or four different middle-value blues, use one blue to eliminate the others. The last problem is that there may still be some shape that is the wrong color. The solution in this case is to find the color that will work.

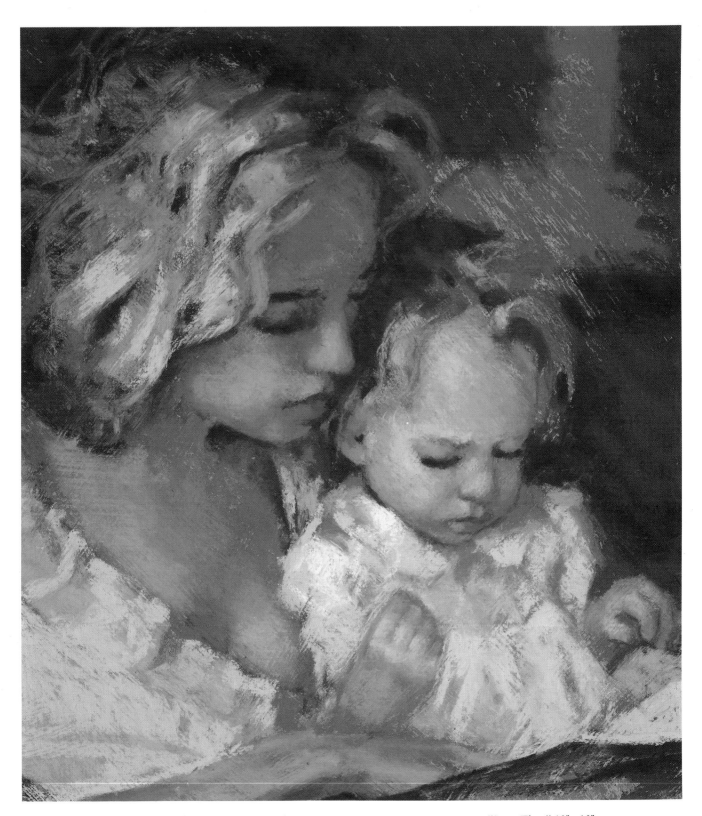

▲ **"Story Time"** 18″×16″
Collection of Lowell and Jesse Hansen
In *Story Time* there is very little intense color.
The small spots of cool green and violet seem
brighter because they are set against these
dull warm colors.

NINE

Underpainting with Color

Most pastel paintings have multiple layers of pigment. These layers result from mixing colors on the painting's surface, from blocking in large shapes and then working over them, or from using one layer of color to unite and harmonize other layers of colors. In a painting with multiple layers, I call the bottom layer the underpainting and the top layers the overpainting. This chapter describes several different ways to utilize an underpainting.

▶ "Going Home" 25″ × 27″

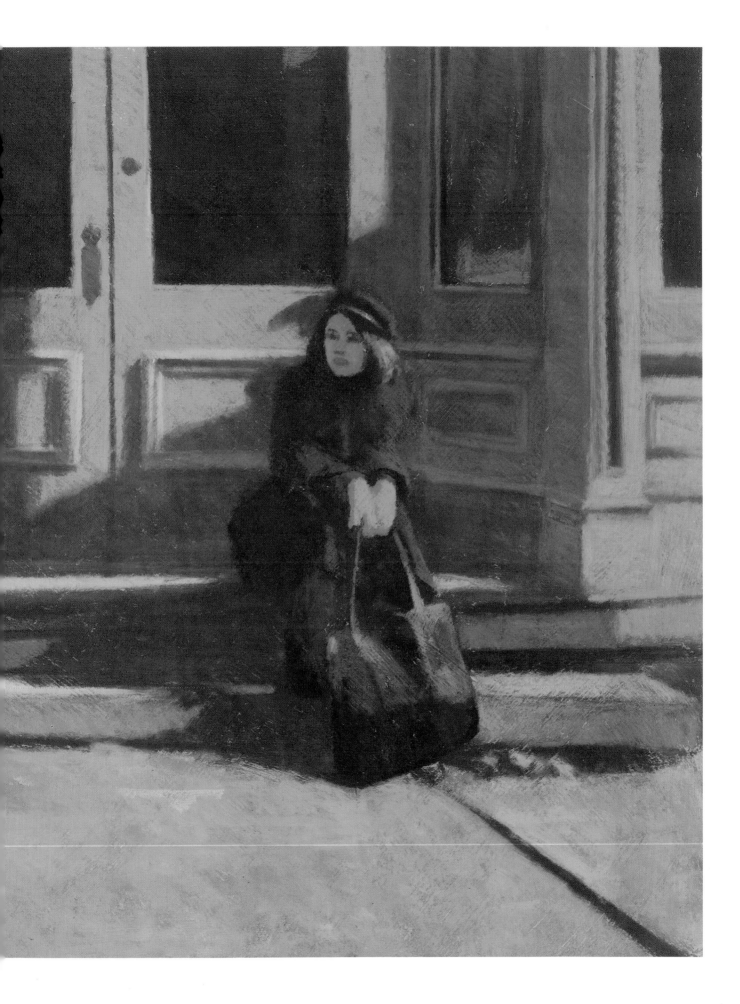

▼ To begin I underpainted the head and body with one continuous color. This established the fact that all the shapes that made up this object were a cohesive unit. Similarly, the underpainting in the background unified all the possible shapes that later would make up the background.

▼ Pamela's skin had an orange glow. She was reclining against a rich violet cloth. All the big shapes in the subject were warm colors. I worried that this would add up to too much warm color. So in the process of breaking down the painting into smaller shapes, I introduced some cool color. Underpainting with cool color was one way to break up the warm color that was to come.

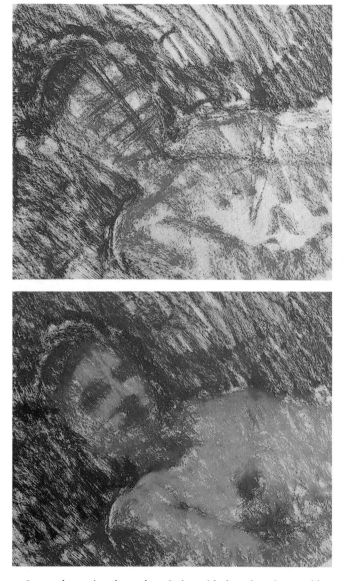

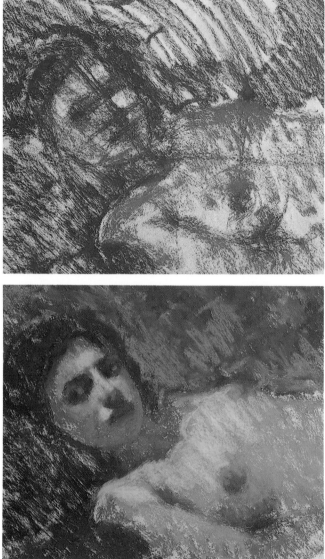

▲ I started covering the underpainting with the colors that would make up the overpainting. Using these colors I continued the process of breaking the painting down into smaller shapes.

▲ I reintroduced the yellow ocher from the underpainting into the shadows. I added blue to the background to keep it cooler so it would recede in space.

How colors mix depends upon the techniques used to apply the pastel and whether or not the underpainting has been fixed. Sprays and fixatives seal the underpainting and limit the mixing process between layers. I don't use fixative in my own work because I favor the textures I can create working one color into another.

I underpaint as a first step toward solving four types of painting problems: controlling and unifying color; creating texture; unifying loosely related shapes; and unifying planes.

Underpainting unifies the many small shapes that make up an object. The underpainting organizes these shapes into a cohesive unit.

When colors are layered, the color on top—the overpainting—dominates the mixture. The underpainting is like the spice in the stew which you can hardly distinguish but which enriches the result. In *Pamela* the green underpainting gets mixed with all the other colors, and because of it all the other colors are slightly greener. In a subtle way it affects each of them. In some places the underpainting shows through as little exciting sparks of aberrant color.

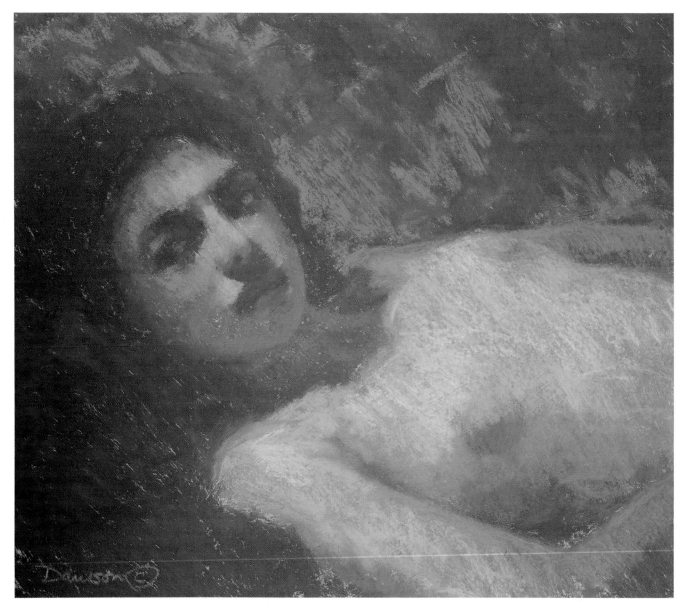

▲ **"Pamela"** 14″ × 16″
I kept the painting loose and impressionistic, allowing bits of the underpainting to show through. As part of this finishing process, I eliminated most of the small spots of light board showing through. These were especially distracting in the darker passages of the painting.

Underpainting with Complementary Color

I think about underpainting with complements whenever I face painting a large area of bright warm color. A large bright red, orange or yellow shape is likely to dominate all the other shapes in the painting. Because of its size and intensity it may distract the viewer's eye from the center of interest. The model for *Mr. Prindible* wore a bright red shirt. I wanted to give the impression that it was bright red without using a lot of bright red in the painting. By underpainting the area with its complement, green, I could accomplish two things. First, where the underpainting and over-painting mix together the green would neutralize the red, causing it to be much duller. Second, where the underpainting and overpainting remain unmixed the red would seem even brighter in contrast to the green underpainting and dull red mixtures. The little spots of bright red would be enough to say that the whole shirt was this color.

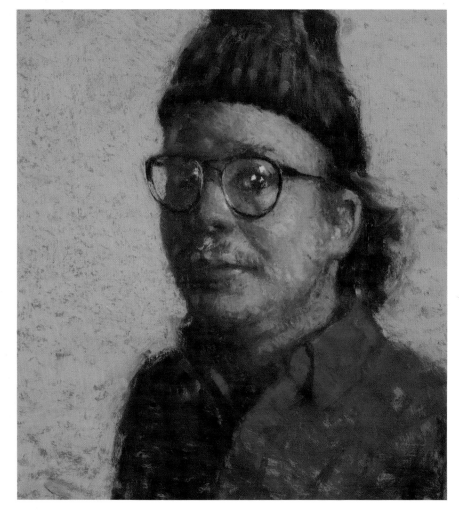

▲ **"Mr. Prindible"** 16″ × 14″
I was afraid that Mr. Prindible's bright red shirt would dominate the painting. To prevent that from happening and still give the impression that the shirt was bright red, I first blocked it in its complementary color, green. Then I painted over the green with red.

Underpainting to Create Texture

Unlike other media, pastel does not lend itself to mixing on a palette. It must be mixed and blended on the surface of the paper or board. There is no end to the variety of patterns and textures that can be created by working one color over another. Colors mixed on the painting surface have a vitality and vibrancy not common to palette-mixed colors. For this reason, even if I have what might seem to be "the perfect color," I prefer to mix the color by combining two or more other colors of pastel. An underpainting is often the first step in creating textures. In *Trees in the Greenbelt* I created textures that were more an expression of my feelings than an imitation of what I was really seeing. As I mentioned before, a vegetable soup is tasty because of the nice big chunks of vegetables in it. A painting may be pleasing because of the textures created by big strokes of color. If you put the soup in a blender you would ruin it. Similarly, if you blend everything in a painting you may destroy it. *Trees in the Greenbelt* is for me a tasty soup.

Sometimes I create textures to solve specific visual problems. In *Near the Headwater* (page 72) I wanted to imitate the sparkling pattern of water tumbling down the stream. I have learned from past experience that it is easier to lay in the dark values in the water and then paint the light values over them. In this way the darks remain under the lights just as they are in the water. Rather than try to anticipate where each little dark shape should go, I underpainted large parts of the stream with dark and middle values. Later I added light strokes of pastel that imitated the textures and patterns I saw. Without the underpainting it would be very difficult to imitate this type of texture.

▲ **"Trees in the Greenbelt"** 12½″ × 14½″
I underpainted the background and middle
ground with a light-middle value of blue. I
then covered this with a light red-violet in the
background and a green in the middle
ground. As I applied these colors I made
the decision to let the underpainting show
through here and there. The texture that re-
sulted broke up the space into a variety of rich
shapes and colors.

▲ **"Near the Headwater"** 13½″ × 15½″
Light reflecting on water is dazzling. The impression is made up of millions of little spots of light. To make these reflections seem as bright as possible, I set them in contrast against darker colors that I had underpainted. Trying to paint the darks after the lights would have caused muddy color, and the darks would have looked like they were floating on the surface rather than underneath.

▶ **"Superior Grocery"** 16″ × 18″
I unified all the loosely related shapes in this painting by underpainting all of them with the same color. Using a cadmium orange I blocked in the shape of the sign over the store windows, the street, the lamppost, and the wall to the right in the painting. I used the same color for the coat of the man on the right, and I used a few spots of the color in the window on the right side. The name cadmium orange is deceptive because the color is actually a dull yellow-green in appearance.

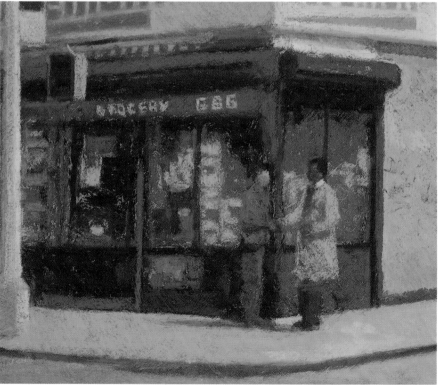

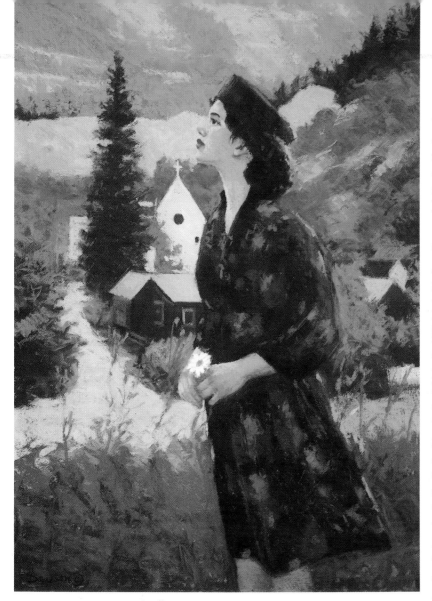

▲ **"Katharyn and the Flower"** 42″ × 29″
In this painting I used a light middle value of blue-green for the underpainting background. Similarly, I blocked in the middle ground where the buildings are located with a slightly darker and greener blue-green. In both cases the underpainting served to unify the colors of all the objects in those planes. To unify the colors in Katharyn's dress I underpainted it with a dark indigo.

Unifying Shapes with Common Color

Shapes that can be unified in a painting are those that already have a strong natural relationship to each other. They may all be part of the same object or structure, as are the parts of the building surrounding the window in *Superior Grocery*. Or they may be related because they are all bathed in the same unique quality of light. With many different objects in the same scene, it would be tempting and easy to pick out a different stick of color for each of them. Doing this could be disastrous, however. If the intended shapes are first underpainted, it is then safer to add other colors without the risk of discord. The underpainting mixes with each of the other colors. The shapes then become related by

virtue of the color that they share. A color used in this way is called a *common color*. Underpainting shapes with one color is a good way to introduce a common color and unite otherwise loosely related shapes.

Organizing Planes

A group of shapes in nature that are naturally tied together make up a plane in a landscape. By underpainting the background plane I can imitate two of the visual phenomena caused by the atmosphere (see Chapter Twelve). I can reduce the contrast between values, and I can shift all the colors toward the cools. For example, the shapes that make up the background plane in *Katharyn and the Flower* are related because they share equally the effects of atmosphere and distance. To unify the shape that made up the background plane I blocked the plane in with a cool underpainting. I chose a color that, when mixed with the other colors, would imitate the color change caused by atmosphere. In addition, where the underpainting mixed with the light values it caused them to go darker, and where it mixed with the darker values it caused them to go lighter. The result was less contrast between the darks and lights.

Underpainting the shape of the dress as I did in *Katharyn and the Flower* is one way to unify the pattern on the dress. After underpainting the dress I broke it down into patterns of light and shadow, treating it as if it were a solid-colored indigo dress. After the light and shadow patterns were established I used these patterns to help me place the red, blue and green flower shapes. The color of the underpainting unified the colors I used in the flowers by mixing with them. The pattern of light and shadow helped me determine where to place the flowers and how the colors should change over the folds.

Painting Negative Shapes

A shape can be altered either by changing the shape itself or by changing the shapes that surround it. Practically speaking, the shape that has our greatest attention is called the *positive shape* and the shapes surrounding it are called the *negative shape*. In this chapter I will describe how to use negative shapes to alter the size and edges of adjacent positive shapes. In a portrait or still life the term negative shape usually refers to the background. The positive shape is usually the shape of the person who is the subject of the painting or the shape of the objects that make up the still life.

▶ **"The Locust Tree"** 20″ × 22″
Collection of Sally Marsh

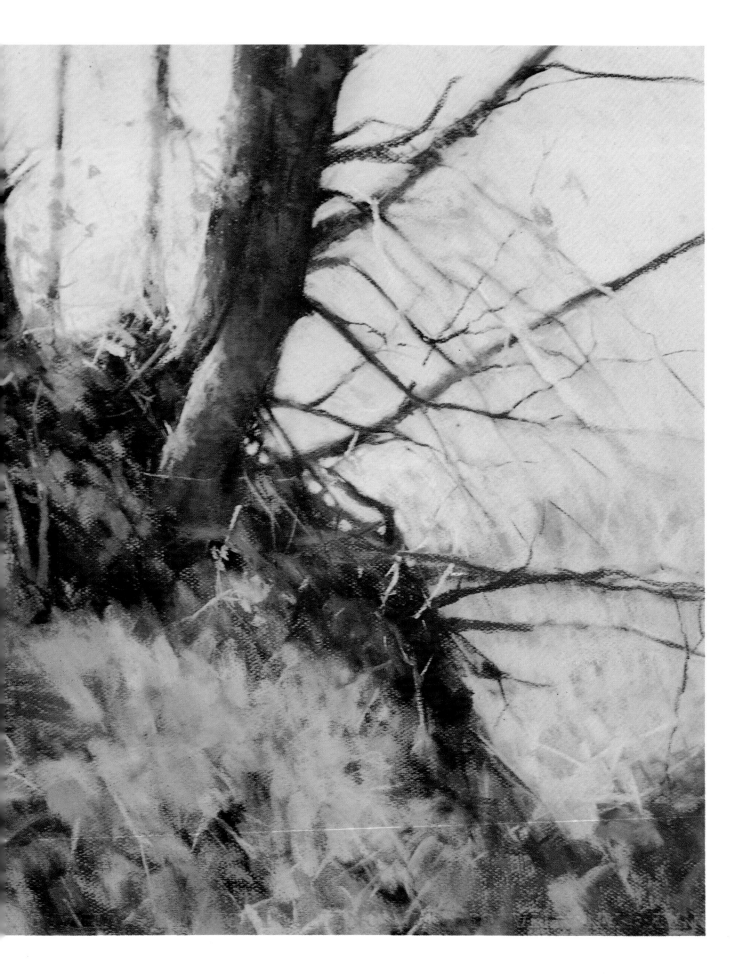

▶ **"Ruthie's Coffee Shop"** 25″ × 27″
Lettering is a good source for interesting
color and design in city scenes. Painting the
negative shapes can produce much more
satisfactory results than trying to render the
letters.

Painting Signs in City Scenes

One clear illustration of the difference
between negative and positive shapes
is the use of words and letters in signs.
The words and letters are obviously
the positive shapes and all the shapes
surrounding these words and letters
are negative shapes. Besides the direct
messages associated with writing, let-
tering and signs break up space with
interesting shapes and textures.

But there are several difficulties as-
sociated with painting words and let-
ters in signs. One difficulty is that it is
troublesome trying to print tiny letters
with big, thick pieces of pastel. An-
other difficulty is that, even if you can
print the letters, it is hard to line them
up, space them properly, and make
them look squared off as if they were
printed. Still another difficulty is that
if letters are the only element in the
painting drawn with line, they are in-
consistent in style with the rest of the
painting. I don't try to print out the
letters with pastel; instead, I chip away
at them using the negative space that
surrounds them. The results are easier

to control and more consistent in style
with the rest of the painting. Depend-
ing upon how accurately the letters are
defined, they may be readable, like the
word "heros" in *Ruthie's Coffee Shop*, or
they may be recognizable as printed
matter but unreadable, like the words
below "coffee."

Sometimes I leave the signs in a
painting unreadable to give the im-
pression that the letters are too small
or too far away to be read. Sometimes I
leave them unreadable to indicate that
they can't be read because they are in
dim light or to suggest that something
has obscured them. I may paint some
signs legibly while leaving others ob-
scure to draw attention to the words in
the readable sign or simply to direct
the viewer's eye to specific parts of the
painting. For whichever reason, in
each case I accomplish the task in the
same way. I paint into the rectangular
shapes with negative shapes as if I
were going to carve out each letter. I
stop short of defining the letters in the
unreadable signs.

This same method can be used to
paint the shape of a window. First the

positive shape of the windows is
blocked in. Then, using the negative
shape of the building, I divide the win-
dow into smaller shapes.

Controlling Edges

At first, painting without line drawing
is intimidating because it is difficult to
imagine how you can construct a
shape without first drawing it. But
lines are really an unnatural element
in nature. Objects in nature aren't sur-
rounded by lines. They are sur-
rounded by edges. Lines have thick-
ness, value and color; edges don't
because they are infinitely thin. When
two shapes in a painting touch each
other, an edge exists between them. If
one of the shapes in a painting, say the
negative shape, is changed and caused
to overlap part of another shape, the
positive shape, then the edge between
the two shapes is moved and the posi-
tive shape is made a little smaller. A
variety of edges can be created by vary-
ing the way the negative and positive
shape are painted into each other.

◀ In this first step the large simple shapes of the sign are blocked in. I try to visualize the groups of letters that make up each word or phrase as a rectangular shape. I paint this rectangular shape the color the letters will be.

◀ At this stage I count the number of letters and divide the rectangle up into an equivalent number of pieces. Since only three of the five letters in "pizza" would be visible, I divided the yellow rectangle into three blocks.

◀ In this last stage the negative space around the letters is used to modify and correct the shape of each letter. If the sign is farther away and I only want to allude to what is written there without defining it, then I keep the shape of the letters more nondescript. This procedure allows me to leave parts of the sign suggestive but not defined, as in the lettering below the word "coffee."

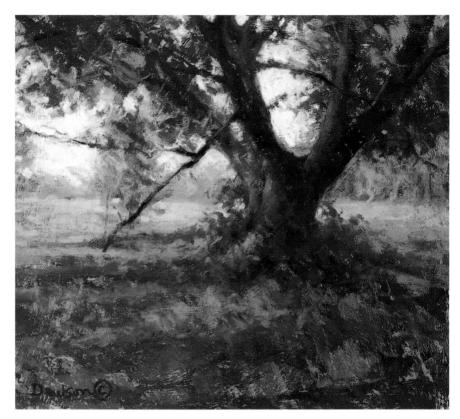

▶ **"August Meadow"** 20″ × 22″
Private collection
When I paint small, open areas of sky within the shape of trees, I paint them one or two values darker than the sky surrounding the tree. I do this because I assume that these small areas of sky are covered with a thin screen of overlapping branches, causing the sky behind it to appear darker. The smaller the opening in the tree, the darker I make the value of the sky. I use the same technique of painting negative shapes into positive shapes to create the edges around these open areas.

Painting Trees

When painting trees, it is natural to try to imitate the pattern of leaves within the tree, perhaps by painting little spots of color all over the surface of the tree. More important than leaf textures, however, are the patterns of light falling on large masses of leaves as well as the irregular edge of the tree as seen against the sky or background. In *August Meadow*, I directed my attention to these large masses of leaves. The textures I used to suggest them were rather nondescript and might have been used to suggest many different objects besides trees. The most important visual clues that the tree is made up of leaves come from its edge, where tree meets sky. I didn't try to paint hundreds of little leaf shapes along the edge. Rather, I blocked in a rough shape for the tree, then by painting the negative shape of the sky into the tree I broke the edge up into leaflike shapes. This negative shape cannot be controlled very accurately. For this reason, the edge ends up having an accidental or random quality.

This accidental quality appears more natural than one created by the deliberate placement of leaves. Other places where the edge is more important than the texture within the shape are: overlapping grassy growths, and large areas of stones or rocks that overlap the water or the embankment along streams. Once you learn to create edges with negative shapes you will discover many other places where this approach will work.

Painting Hair

I routinely suggest the texture of hair by the appearance of the edge. As with trees, I suggest the edge by painting the negative shape of the background into the shape of the hair. In *Michael's Lady*, the model's hair had many small open curls or ringlets. I indicated this texture by painting curl shapes on the edge of the hair set against the negative shape of the background and the negative shape of her face and neck. (Note that any shape can be considered a negative shape if it borders a shape you are concentrating on.) I

brought some of the background color into the hair, opening up the shape of the hair and making it appear softer. When the edges are defined by painting the negative shape into the positive shape, the style of application is consistent with the style of application in other parts of the painting.

Pastels are too thick to draw hairs. The illusion of hair is less dependent upon visible individual hairs and more dependent upon how light and shadow fall on locks of hair. Combined with the characteristic edge of hair, this completes the illusion.

Other shapes that should be defined by the negative shapes around them include the mouth and the contour of the face. I usually paint the lips larger than I intend them and then trim the upper lip using the upper mouth. The edge of the face often varies from hard over the cheekbone to soft over the cheek. I use the negative shape of the background or hair to trim up the shape of a face and to make the edges softer where they should be soft.

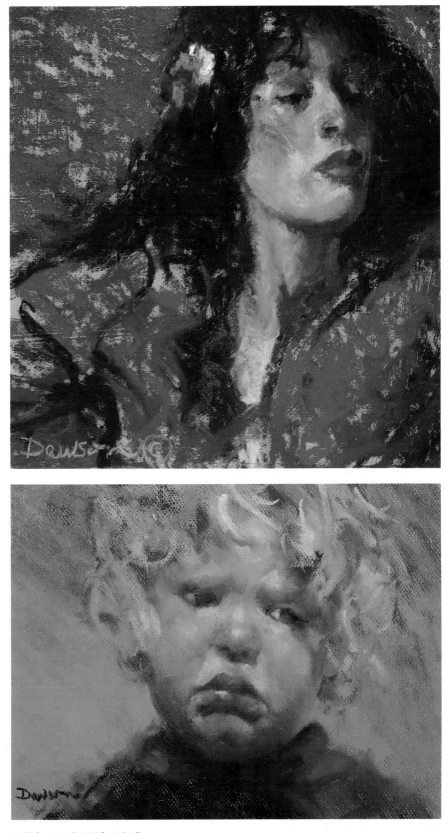

▶ **"Michael's Lady"** 13″ × 14″
Collection of Bonnie Thoma
I blocked in a larger shape for the model's hair than the shape that appears in the finished painting. I often do this with hair so I can trim up the hair shapes later with the negative space of the background.

Hard and Soft Edges

An important property of edges is their degree of hardness or softness. One of the ways to control this property is to paint negative shapes into positive and vice versa. There are several reasons edges appear hard or soft in nature. Edges get softer as they get farther away. I describe this property in greater detail in Chapter Twelve. Generally, making an edge soft causes it to recede; making it appear hard causes it to come forward. Edges surrounding objects with a great gradual curvature are soft, as in the outer edge of Tim Roy's cheeks in the painting *Tim Roy*. Objects with a sharper curvature, such as his ear, have harder edges. The edges of cast shadows are harder the closer they are to the object casting them, on Tim Roy's forehead. The shadows on his forehead are hardest where they are closest to the locks of hair casting the shadows. In other places the shadow is diffuse, almost without an edge, because it is farther away from the hair. Finally, shadows on curved objects are soft, like the shadows on Tim Roy's cheeks. The sharper the curvature of the object (the closer it approximates an abrupt fold), the sharper the edge of the shadow. Don't confuse this last observation with the first. Here I am talking about shadows; there I was talking about edges (external contour shapes). The shadows on Tim Roy's chin are harder than on his cheek because the curvature of his chin is sharper.

▲ **"Tim Roy"** 10½″ × 13½″
Collection of Steve and Carol Patterson
I painted the shape of Tim's head of hair larger than I intended, then I trimmed the shape using the negative shape of the background. I softened the edge of his hair by painting background color into it, intensifying the feeling that his head is going back in space.

ELEVEN

Painting Backgrounds

Many of my students complain of difficulty painting backgrounds. This is most often because they ignore the first rule about backgrounds, which is: *Paint the background right away.* Commit yourself to the background at the beginning of the painting process. Don't put it off until the end of the painting! Remember this negative rule: If you want problems painting backgrounds, paint them at the end of the painting process after everything else is completed. It never works. A background painted at the end of the painting process alters or destroys all the previously resolved color relationships. This happens because we judge colors in relation to the colors surrounding them. If I paint a head study without a background, I instinctively select colors that look good against the natural color of the board or paper. Later, if I fill in the background, I change how all the other colors look because I have surrounded them with a new color. In addition to changing the color relationships, adding a background later also changes the value relationships in the painting. When I painted *Stephen* I blocked in the big shape of the background right after I blocked in the big shapes in the figure. This allowed me to visualize how the composition would look. With the background blocked in I could determine how dark or light each of the shapes in the figure should be.

▶ **"Stephen"** 30½″ × 24½″
Collection of El Paso Art Foundation, Colorado Springs, Colorado

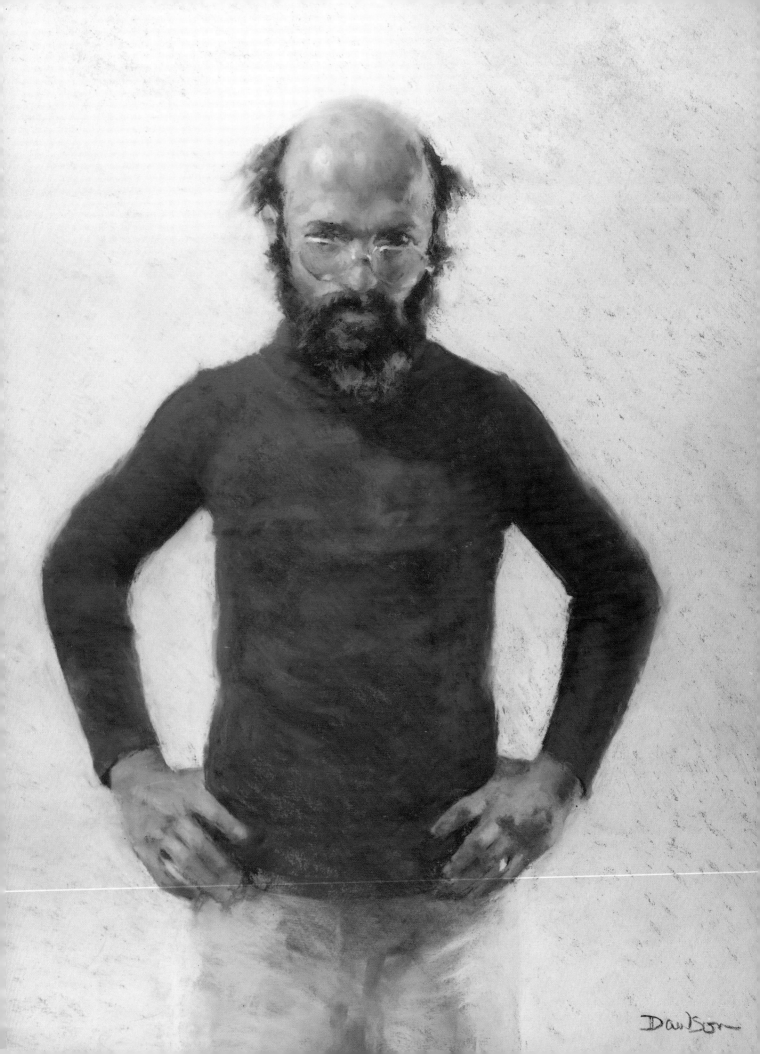

Four Methods of Painting a Background

Every method of painting backgrounds can be understood as a variation on one of four basic approaches. These are: painting a simple, solid-colored background (such as a solid-colored wall); painting an imaginary background (a made-up arrangement of shapes and colors); painting a representational background (what is really there); and painting an abstraction of what is really there (simulating the arrangement of the actual background with nonrepresentational shapes).

The Plain Background

This is perhaps the simplest approach. You pick a color or a combination of colors and paint in a solid-colored background. You might ask, Why bother painting a solid-colored background? Why not make it a vignette and leave the background the color of the paper? There are several reasons. The first and most obvious is that it allows you to use a color in the background not available in a paper. Second, you can create textures and gradations that are more interesting than plain paper. Last, you can invent a background with little risk to the composition.

To determine if a composition will work well with a solid-colored background, try to visualize the subject as a silhouette. If the composition is interesting as a silhouette, it should be equally interesting against a painted background. A few things must be kept in mind. As I have done in *Taking Her Stand*, try to keep the background color dull so that the brightest colors will be in the center of interest. If you

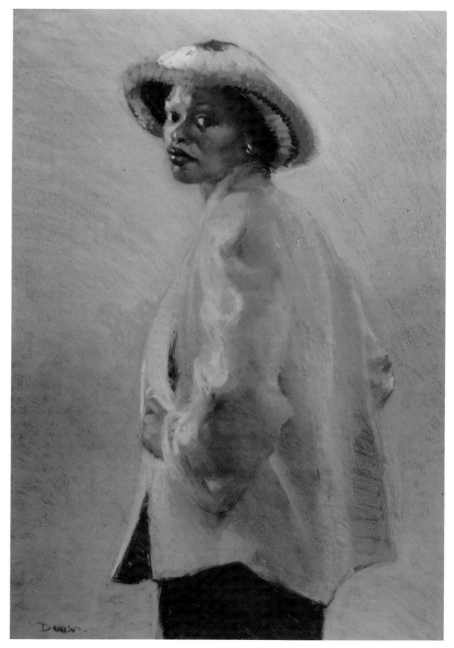

aren't certain which color to try, try one or more of the colors you are using in the figure. This ensures color harmony and helps keep your palette simple. If you use a new color in the background, then try to use the background color someplace in the figure.

▲ **"Taking Her Stand"** 33½″ × 23½″
Collection of Mr. and Mrs. Leonard Freis
In this painting the background evolved as the figure evolved. When I first painted it, the background was a light, dull raw umber. This worked but was not very exciting. As I worked on the figure, I would occasionally try colors in the background that I was using in the figure. I tried light-blue highlights on the back of the jacket and decided to try this same color in the background. The results were pleasing, but my instincts told me I might not like it if the whole background was that color. I started at the top and worked down. When I got halfway down I stopped.

The Invented Background

The invented background is one of the most commonly used and least successful methods. I avoid it. When it is done successfully, it is usually done in this way: At the same time that the artist introduces a color in the figure, he uses a bit of it in the background and maintains the distinction between background and figure by using the colors in different proportions. For example, a color that is used sparingly in the figure may be used in greater proportions in the background and vice versa.

The biggest shortcoming to this method is that it depends upon the artist's imagination for the placement of color and shapes. Frankly, the imagination is a very limited thing; it needs the stimulus of the real world, which this method fails to provide. The artist who relies on this method tends to repeat the same arrangement of background shapes over and over again in successive paintings.

Children of the Suriname Rain Forest is a rare example of my inventing a background. The children were sitting in front of a wooden shack. The value and color of the wood in the shack were nearly the same as that of their skin. The composition, as it stood, was weak and colorless. I looked around for a suitable substitute but couldn't find one I liked, so I invented this one. I based the shapes in the background upon my memory of some landscape drawing I had done a few days earlier. The background was invented, but not out of the void; it came out of a memory of a real-life experience.

Painting Representational Backgrounds

This approach is great when the background contributes to what you are trying to say in the painting. But often the background has nothing to do with the person you're painting or with

what you are trying to communicate. The danger for most of us is the temptation to paint the background simply because it's there—in other words, to paint without thinking.

I spend a lot of time looking for ways to devise meaningful backgrounds. When I paint portraits I usually ask if I can work with the subjects in their homes. This allows me to explore the use of their rooms, their furniture and their knickknacks as part of the background. When I painted *Constance,* I interviewed the subject and her husband. I asked them in what part of the house she spent the most time, which was her favorite chair, what activity was she most often

▲ **"Children of Suriname Rain Forest"**
22″x20″
I wanted the invented background to be green in the finished piece. Yet I wanted to make sure that the green would be under control so it wouldn't dominate the figures. The simplest way to do this was to use a warm color underneath. I underpainted the background with a warm burnt sienna because I had already used some of it in the flesh. For the lightest blue-green in the background I used the cool highlight color I had used in the flesh.

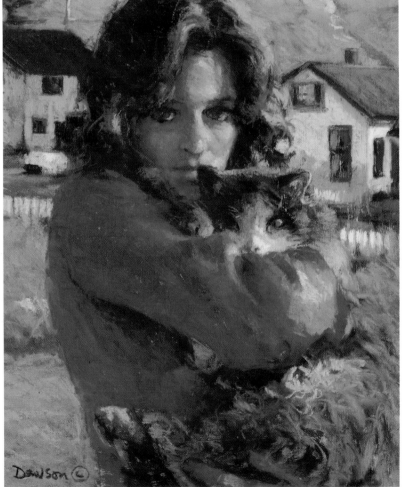

◄ **"Constance"** 20″ × 22″
Collection of Constance Simantob
I painted Constance in her favorite chair in a corner of her favorite room. She had collected some wonderful antiques, like the candlesticks and clock in the background. I didn't simply find this arrangement and have her pose against it, although that happens on occasion. I gathered the objects and arranged them for the composition. Still, everything was hers and contributed to what I wanted to say about her. In addition, they enriched the background by breaking up the space into interesting shapes.

▼ **"Sharon"** 20″ × 16″
Collection of Marti Foster
Light and shadow on the face give clues to the light and shadow in other parts of the painting. For example, it is often difficult to determine where the break between light and shadow should be in the hair. By looking at the line that separates light and shadow on the forehead, I can often determine where the separation should be in the hair.

engaged in: reading, cooking, and so on. I tried to form a mental picture of who she was and of where and how I should paint her. If possible I wanted the background to be part of her.

The painting of *Sharon* was done in quite a different way. This was not a commissioned portrait. It wasn't necessary that the background reflect who Sharon was but that it contribute to the feeling of the painting.

In the end Sharon modeled for me in front of a brick wall. The background did nothing for me. I could have treated it like a solid-colored background, but somehow the pose seemed to suggest a story that was only partly told. I set the initial work aside, determined that sooner or later I would find a background that would work with her. Eventually I found a landscape setting that I thought would work. Using the initial work of Sharon and the landscape as reference material, I started a new painting. I developed the background and the model simultaneously.

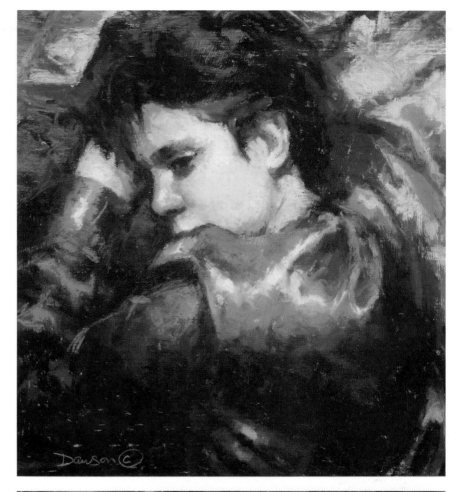

▶ **"Candace"** 15″ × 14″
Collection of Dean and Tracy Curry
The background in *Candace* is just an arrangement of cloth. When I painted this I was more interested in using the arrangement of the shapes and colors than in trying to really paint it so it looked like cloth. I indicated the wrinkles and folds wherever it pleased me, but not with the same fidelity I used in painting the cloth in her blouse.

▼ **"Portrait of Mari"** 12″ × 11″
Collection of Dr. Gertrude Hausman
In *Portrait of Mari* the subject posed outside. The background is an abstraction of the garden and trees in her backyard. When I painted this, Mari was a teenager. I searched her home and, in particular, took a close look at her room for background material. Still I knew the painting was going to be small and therefore a head study. This meant that the background, no matter how interesting, would occupy just a little space around her face. I settled on the garden because the colors worked so well with Mari's red hair, and the outside light was gentle on her face.

Abstracting from What Is There

Often the objects or setting behind the model are of no importance, yet the patterns of color and value may be interesting. A useful approach is to abstract the objects that are there, using their shape, color and value without making any of it recognizable. The background in *Candace* is an abstraction of a created background.

The important difference between abstracting a background and inventing one is that the shapes, colors and values in an abstracted background are not dependent upon your imagination. In *Portrait of Mari* I changed the relative size and position of some of the shapes in the background. It was easy to visualize these changes, they were just variations on what was really there. The background in *Portrait of Mari* is an abstraction of a background found outside.

Ninety percent of the time when you instinctively stop working on a background, your instincts are probably telling you something. What they

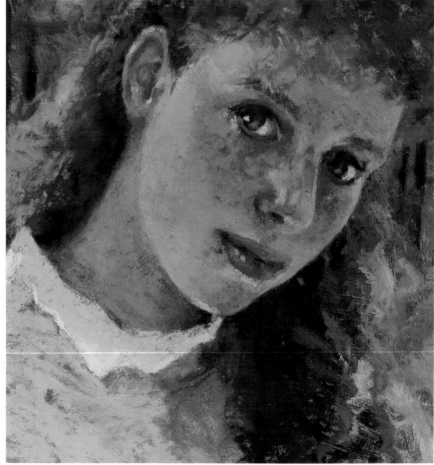

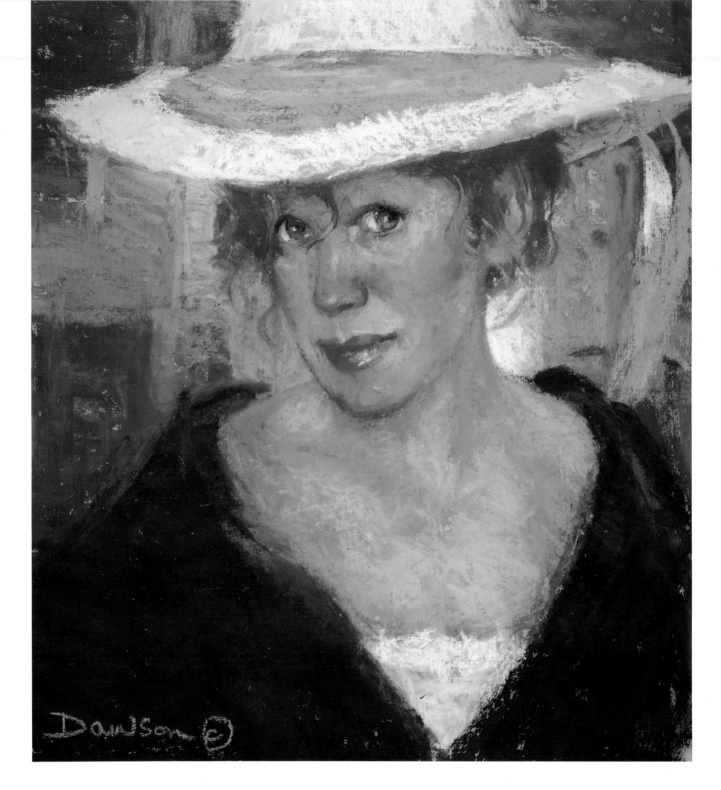

Dawson ©

are usually telling you is that if you continue, you will lose something. The question you must ask is, What is at risk of being lost? The most likely possibilities are colors, value, textures, edges or shapes. If you can identify what it is you are afraid of losing, then you can hold on to it. In *Kemper's Daughter* I had just started to block in

the background when my instincts told me not to play with it anymore. I realized it was the simple shapes and textures I was afraid of losing. Although it was necessary to work on it a bit more, I was careful not to disturb the shapes and textures. The background in *Kemper's Daughter* is an abstraction of an interior.

▲ **"Kemper's Daughter"** 15″ × 17″
Kemper's Daughter is a painting of my wife, Sue. She was standing in a room with a window in the far end and to her back. I liked the way the light from the window created a glowing rectangle in back of her. I liked the way it silhouetted her hair and neck in light. In addition, I liked the colors of the walls and furniture in back of her. None of the objects were important, however. I felt that the actual objects in back of her would not contribute to the painting but would distract the viewer from her. I chose to use the shapes and colors but to abstract the objects.

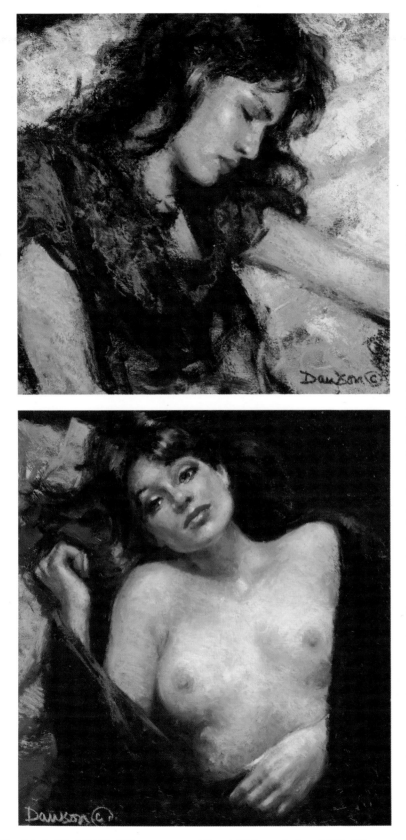

Using Cloth

I keep several boxes of cloth on hand. These include a wide selection of fabrics in different colors. Lacking a better idea, I like to throw the cloth over pillows, over the back of couches, or staple it to the wall to create a background. I often ask the model to participate in this process by picking out the cloth she likes best. I have found that most people know immediately which colors will work for them and which ones won't. This saves me much trial and error. By having the model select the colors I avoid falling victim to the habit of always choosing the same color combinations. The model's input encourages me to try patterns and colors I might not have thought of. It also personalizes the background so that it reflects the model's personality and mood. Patricia selected the cloth used as the background for *Patricia in Black*. I abstracted the patterns of folds so that the detail wouldn't distract from my model, who was the center of interest.

When I use cloth in the background, I think of it as painting with fabric. I apply the same color and compositional principles as with paint. I keep my palette simple by not using too many colors of cloth. I try to organize the composition into big, simple value patterns. To this end, if the model's hair is dark or she is wearing a dark piece of clothing, as in *Solomon's Song*, I may drape dark cloth in the background so that her hair or clothing partly overlaps it. This unites the small dark shapes, forming one or two large dark shapes in the composition. In addition, it opens up the contours of some of these dark shapes so that the edges vary from hard to soft. The same logic can be applied to the light shapes.

▲ (Top) **"Patricia in Black"** 17″×17″
Collection of Steve Rose
I chose to paint the cloth behind Patricia a different pink than it actually was. This was something that evolved more than it followed my plan.

▲ (Above) **"Solomon's Song"** 22″×20″
Collection of Thomas Messman
I had the model pick out some cloth which I threw over some pillows. In *Solomon's Song*, I arranged the cloth so that the model's dark hair and her robe would overlap the dark cloth. I took care to design the composition with patterns of light and dark values. I painted the cloth pretty much the way it appeared.

Creating Depth with Pastels

Talking about putting depth in your painting is a bit different from talking about color, backgrounds, or negative space. While art elements like color, line and value are really there, depth is simply an illusion created by using the elements just mentioned.

The illusion of depth in a painting is created by imitating one or more of the seven observable ways the eye perceives depth in nature. The first two of these observations are: (1) as space recedes, *objects that are close overlap the objects that are farther away*, and (2) as space recedes, *objects appear to get smaller the farther away they are*. This is the principle of linear perspective.

▶ **"Mountain Hamlet"** 33″ × 33″
Private collection

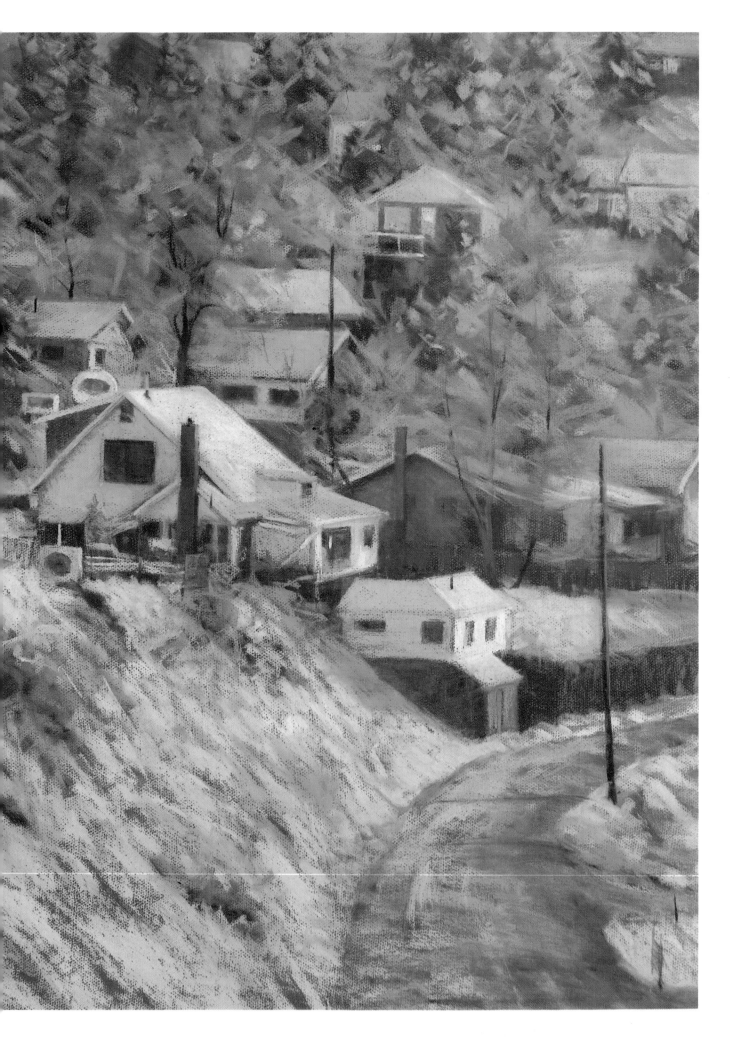

▲ In step one I divided the space into three planes. The lower line separates the foreground and middle ground. I visualized the hay bundle and fence as part of the foreground and sitting right on this line. The upper line separates the middle ground and background. I often place the center of interest on the line separating the foreground. This allows me to contrast the center of interest against the change in color, edges, detail and contrast in the other planes.

▲ I blocked in the pattern of dark shapes in the foreground and background planes using the same stick of color. According to the principle of diminishing contrast, the darkest darks should be in the foreground if possible. I plan to lighten the darks in the background as the painting proceeds.

▲ I blocked in the sky with a yellow color, bringing part of it down over the background. This lighted part of the background and softened the edges where the background meets the sky. I blocked in the background with an Indian red, a red and a violet. I used the Indian red where the colors will encircle the setting sun. The principle that color gets cooler implies that if colors this warm are in the background, then touches of even warmer color (yellow-oranges or yellows) will have to be used in the foreground.

◄ (Previous page.) In *Mountain Hamlet* the country store in the foreground overlaps three of the buildings in the background. The buildings behind the country store are also noticeably smaller, indicating they are farther away. If these two principles were not working properly, the painting would seem flat no matter how well the other principles were handled.

▲ I blocked in the middle ground and foreground with the same two colors: a dark green (olive green) and a lighter yellow-green (cadmium orange). I separated the two planes by using these two colors in different proportions. I used more of the dark green in the foreground and more of the yellow-green in the middle ground. This is the reverse of the order these colors should be in if color is getting cooler as it goes back in space. I knew this; I also knew I would be covering the middle ground with a third color as well as adding an even yellower green in the foreground.

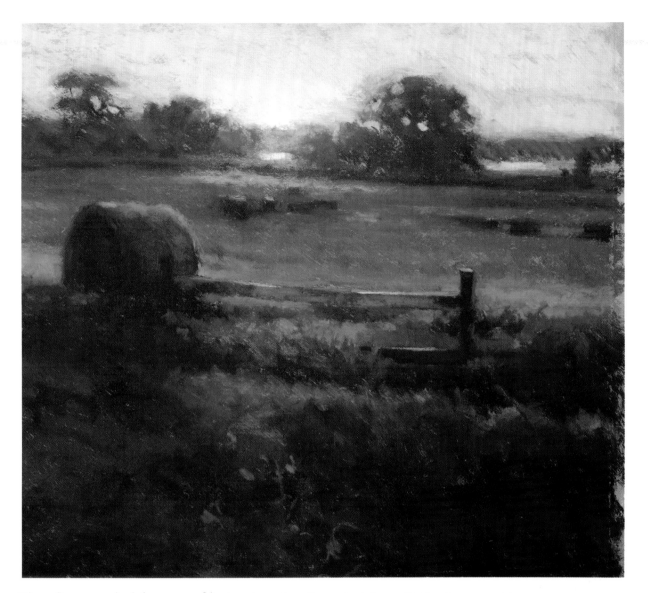

These first two principles are used just the way they are stated. It is not necessary to alter or exaggerate them in any way. The following five principles, however, must be exaggerated in the painting. In nature they are so subtle they may go completely unnoticed. If this artistic overstatement is done well, it will appear natural and the viewer won't be aware of it. These principles are: (3) as spaces recedes *detail is lost*; (4) as space recedes *edges get softer*; (5) as space recedes *color becomes cooler*; (6) as space recedes *contrast between values diminishes*; and (7) as space recedes *color diminishes in intensity*. This last principle is a variation on the fifth principle, that color becomes cooler with increased distance. It is not as reliable as the other six. I rarely refer to it when I am painting.

To organize the exaggeration of these last five principles I divide the space into planes. Planes are divisions of space in which objects at roughly the same distance from the eye are grouped together. Objects close to the eye are grouped into the foreground plane. The most distant objects are grouped into the background plane. Objects at an intermediate distance between these two extremes are grouped into the middle ground plane. In the painting *Rolled Hay* I used lines to divide the space into foreground, middle ground, and background. I treat the foreground and background as being at opposite ends of the scale for each of the five different principles. For example, using the principle that detail is lost as space recedes, the background is at that end of the scale where there is little or no detail. The foreground is at the opposite end of

▲ **"Rolled Hay"** 17″ × 19″
Collection of Drs. Laura and Hubert Thomason
I corrected the color scale, making sure that the yellowest greens were in foreground vegetation. I made sure that the warmest warms were also in the foreground, in the touch of yellow on the top of the fence rail and the yellow-orange on the top of the hay roll. I eliminated the rest of the darks in the background so that none would be as dark as the darks in the foreground. I further softened the edge separating background and sky while I sharpened up the edges of the fence and hay roll. I developed the textures in the foreground to give the illusion of detail in the grass, fence and hay roll while at the same time keeping the background and middle-ground shapes simple and devoid of detail.

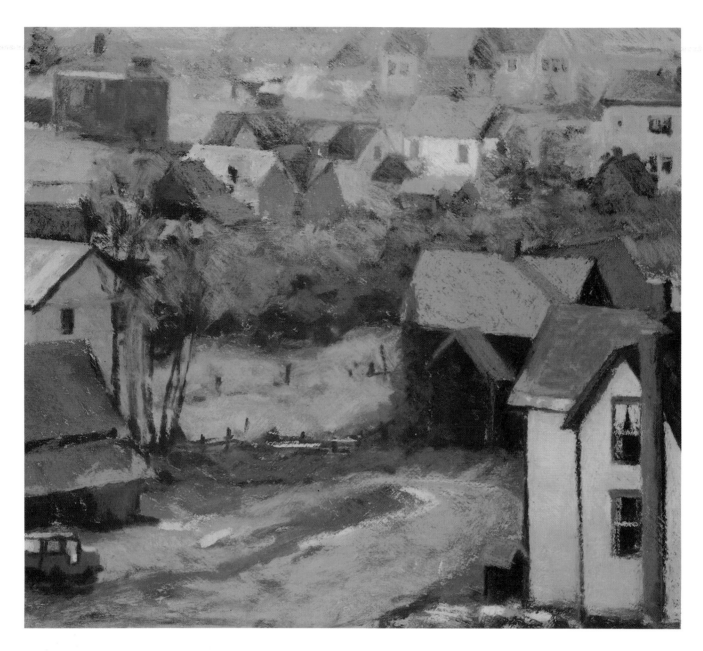

the scale where there is detail. The middle ground is the transition between these two. On the edges scale, I use some hard edges in the foreground and soft edges only in the background. I use my warmest colors in the foreground and keep the background cool. I create the greatest contrast between values in the foreground by having my darkest darks and my lightest lights there. The single most consistent mistake I see students make is taking a shortcut and skipping the use of a line to separate the planes.

Detail Is Lost

As space recedes *detail is lost*. This happens for several reasons, mainly because most of the time our eyes are focused on what is close, not what is far away. This means that the background is usually out of focus. A second reason we see less detail at a distance is because the image we see is made up of thousands of dots of value and color, much the way a printed image appears under a magnifying lens. The amount of detail we can see is limited by the number of dots that make up the image. At a certain point the details get so small they slip between the dots.

It is necessary to use only a few carefully placed details in the foreground to give the illusion of detail. In the painting *Village Road* the smallest shapes used in the background, the windows and chimneys, determined

▲ **"Village Road"** 21″ × 23″
Collection of Anne and David Kleinkopf
The only details in this painting that distinguish the foreground from the background are the detail of the jeep on the left, the curtains in the windows on the right, and the fence posts along the upper edge of the foreground plane.

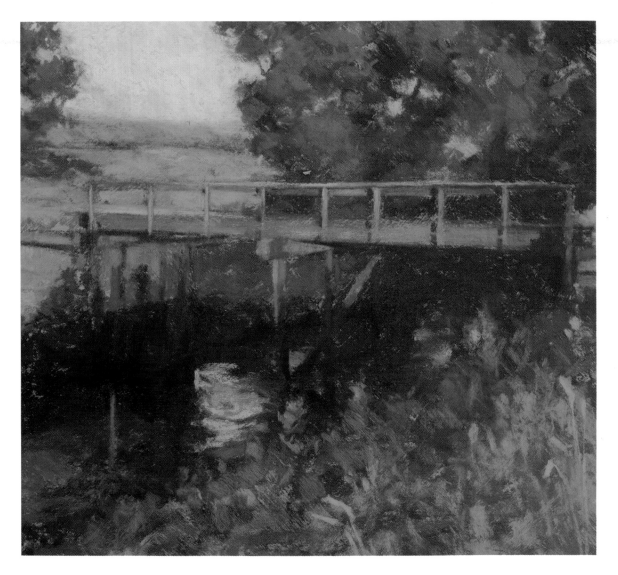

the degree of detail needed in the foreground. Since I could see the windows and chimneys in the background, I needed to imply that I could see details within the windows or chimneys in the foreground. I try to keep the backgrounds simple as I work. The simpler the background, the less detail I will have to use in the foreground. At the end of the painting I add a few details in the foreground to bring it forward.

The pencil illustrations that accompany these paintings show the line separating foreground and background.

Edges Soften

As space recedes *edges get softer*. This is really a variation on the same principle I just described. Edges are really a type of detail that gets lost as space recedes. Edges get softer because the far-

ther away they are, the more out of focus they are likely to be.

It is difficult to observe this phenomenon of the background being out of focus because our eyes refocus quickly when we look from foreground to background. To prove to yourself that this really happens, hold a thumb up in front of your face as if you are measuring something. Focus on your thumb. Without taking your eyes off your thumb, notice that the objects behind your thumb are all out of focus.

Conversely, when your eyes are focused on the background, the foreground is soft and out of focus. Although this may be acceptable in a photograph, a painting with sharp edges in the background and soft edges in the foreground usually just looks unfinished. In *Canal Bridge* the background shapes are all soft and diffuse.

▲ **"Canal Bridge"** 22″ × 24″
In *Canal Bridge* I brought the sky down into the edge of the background plane, softening it at the horizon. I painted one color into the other, causing the edge to be softer. I could have painted a transitional value of another color between the two shapes to soften the edge. A third approach is to scumble across the edge with one color. That is similar to what I did here, except that scumbling results in an edge that is softer because it has been broken up in an irregular way.

▲ **"Silver Plum"** 22″ × 24″
Collection of Susan J. Brookman
In the painting *Silver Plum* I divided the space into two planes. As I looked at the town, there was little noticeable difference between the colors in the background and the colors in the foreground. If anything, there was more of a value difference than a color difference. The angle of the mountain behind the town caused the snow to look slightly darker in value. I exaggerated the shift in color to make the separation in plane more dramatic. I painted all the snowy shapes a blue-green in the background and restricted the use of all the yellows, oranges and reds to the foreground shapes.

Colors Become Cool

As space recedes *color becomes cooler.* This happens because the air acts like a pair of blue sunglasses filtering out the warm light. The farther away an object is, the more air between you and that object, and the more the air behaves like sunglasses. When I paint I treat the objects in the foreground as if I am not wearing sunglasses at all and treat the objects in the background as if I am seeing them through a pair of blue sunglasses. I treat the middle ground in a manner halfway between these two extremes, as if I am wearing light blue sunglasses when I look at it. The shift in color from warm to cool is predictable based upon the order in which different colors of light are filtered out. Yellow is lost first, then orange, then red, green, violet and last of all, blue.

When I am speaking of depth I consider yellow the warmest color, be-cause it is the first color filtered out by the air as objects recede. When I am not talking about this principle, however, and use the term "warm color" in a general sense, I think of orange and red-orange as the warmest colors because they evoke more the feeling of heat.

In *Silver Plum* I used warm yellows, reds and oranges in the foreground and only blues and greens in the background. This gives the painting a strong dramatic quality of light. As in many of my paintings, there really isn't a middle ground, just a well-defined foreground and background. When a middle ground does occur, it usually isn't planned. It usually evolves naturally as the transition between these two planes.

Contrast Between Values Diminishes

As space recedes *contrast between values diminishes.* This means that the light values get a value or so darker and the dark values get several values lighter. The result is that the contrast between them decreases. The reason it happens is twofold. The light values get darker because, as I explained earlier, it is as if you are looking at the distant objects through a pair of sunglasses. Therefore the distant light objects appear a little darker than those in the foreground that are seen without the sunglasses effect. The dark objects, on the other hand, get lighter as they go back in space. The moisture and other particles in the air reflect a certain amount of light, causing a haze. The more air there is between you and the dark object, the more the object gets filled in with a light haze. In *Under the Cottonwood* I painted the background with little contrast in values, as if it were seen through just such a haze.

▲ **"Under the Cottonwood"** 41″ × 41″

Private collection

In *Under the Cottonwood* everything from the horses and trees forward is foreground. I exaggerated the shift in color, making the background much cooler. I divided the background space into simple shapes with values that were very close to each other. This is at sharp variance from the foreground where the contrast between values is much greater.

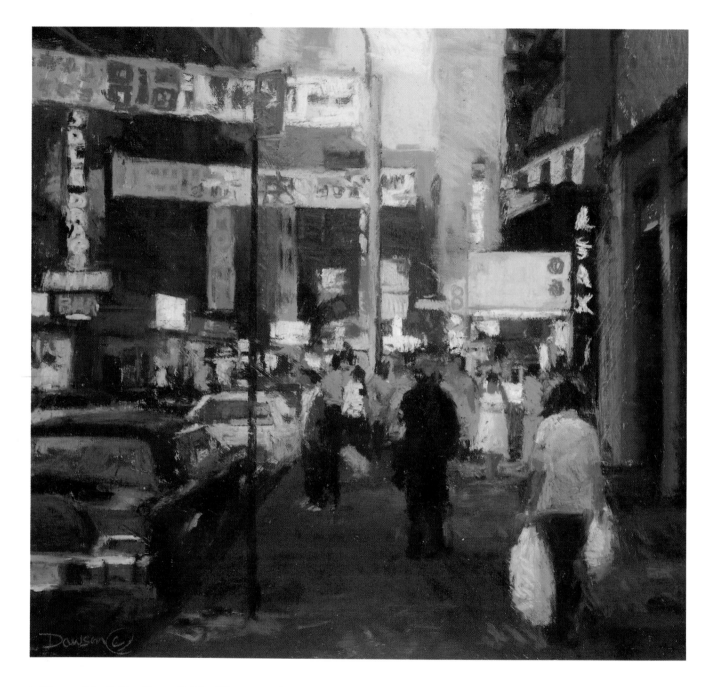

▲ **"Street of the Golden Dragon"** 18″×20″
Collection of Richard and Jo Ann Minner
As the people who are being painted are far-
ther and farther away, they need to be repre-
sented with simpler and simpler shapes.

Application to Any Subject Matter

These techniques for creating the illu-
sion of depth can be applied to any
subject matter—landscape, cityscape,
figure or still life. I used landscapes as
examples simply because it is easier to
visualize depth in a landscape prob-
lem. In addition, these principles are
independent of the depth involved.
They work equally well over depths of
five inches or fifty miles.

There are some problems that may
make it awkward to use one or more
of these principles. For example, sup-
pose you are painting a landscape with
a patch of sunlight in the middle
ground while the foreground is still in
shadow. The problem may force you
to abandon the notion of having
greater contrast in the foreground.
You may have to rely upon the other
principles to create the illusion of
depth. It is not necessary to use all of

these principles in every painting. A painting may be successful when just one, two or three of these principles are skillfully applied. In *Street of the Golden Dragon* I separated the foreground and middle ground with a line just as I would a landscape.

Sometimes it is helpful to think of the foreground plane as a silhouette. This is especially useful when the line that would separate the planes is hidden behind shapes such as buildings. In *The Denver Parish* the line would be completely hidden. Drawing in a line where I think it would be is more of a distraction than a help. Instead I visualize the foreground as silhouetted against the background.

It is important to remember that a plane stretches from one side of the painting to the other. It is not a single object isolated in the middle of the composition. In the painting *Doña Theresa* the figure is an important part of the foreground plane, but it is only one of the elements, no more important than the trees and rocks and other objects.

▲ **"The Denver Parish"** 20″ × 22″
Collection of Dr. and Mrs. Wm. E. Meacham
If I had to pick the one principle that is least important in this painting it would be that edges get softer with increased distance. In fact, all four principles are working well in this painting.

▶ **"Doña Theresa"** 39¼″ × 33″
Collection of Charles and Jule Jewell
Diminishing contrast and colors getting cooler are the primary principles at work in this piece. The warm flesh tones and the dramatic contrast of sun spots against shadow cause the figure to stand out against the cooler-colored background.

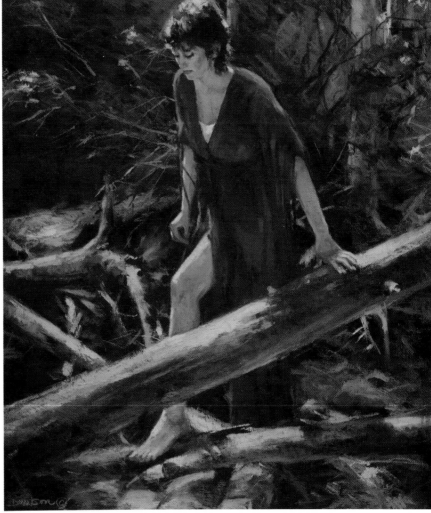

THIRTEEN

Capturing Light

Like creating depth, capturing light is also a kind of sleight-of-hand accomplished by using the familiar art elements, particularly color and value. With a better understanding of how light affects the objects it illuminates and casts in shadow, you can create a kind of magic that can make your painting appear to be illuminated from within. Because of the purity of pastel pigments, it is an ideal medium for capturing that magic.

Every light source has a dominant color that can be identified as orange, yellow, blue, and so forth. In addition to its dominant color, a light may have a broad spectrum and radiate other colors of light as well, or it may have a narrow spectrum and radiate just the dominant color. Generally, the more striking or intense the dominant color, the narrower the spectrum of light. In the painting *Kipling Woods*, the light was a setting sun of intense yellow-orange color. The intensity of the yellow-orange indicated that the light source had a narrow spectrum and wasn't radiating much of other colors of light. The green trees and grass didn't look green in this light. This confirmed my suspicion that there wasn't much green light for the green objects to reflect.

▶ **"Kipling Woods"** 14″ × 14″
Collection of Joseph V. Giffuni

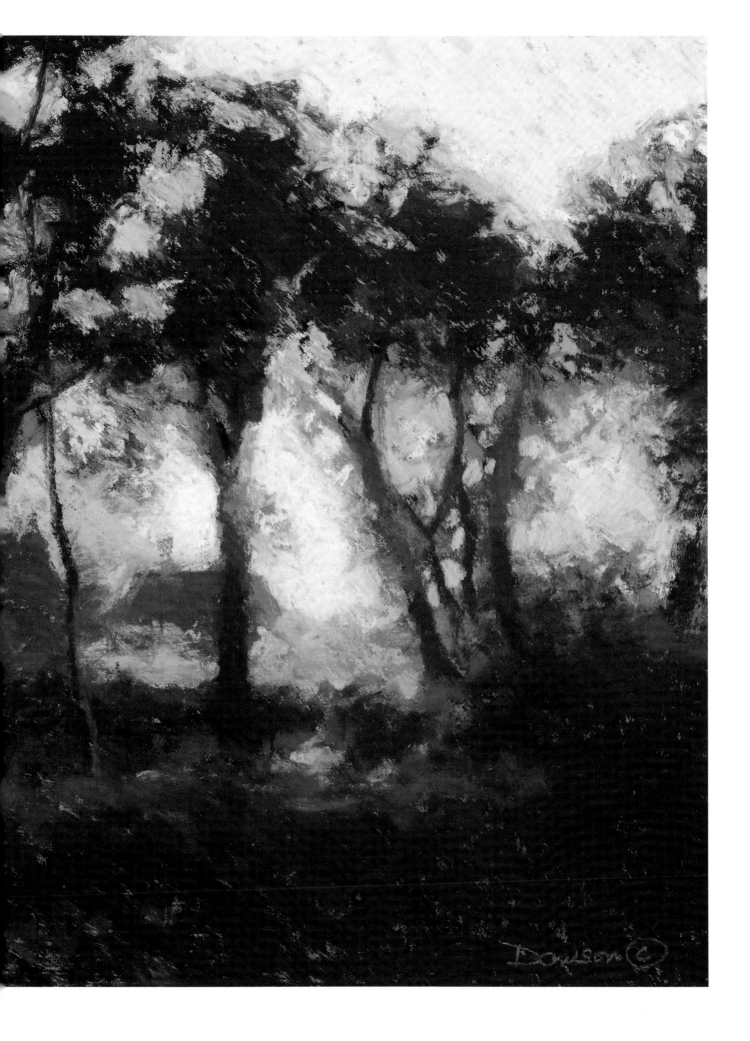

▲ Here is a color wheel rotated so that orange-yellow is at the top indicating the color of the light source.

Almost all lighting can be categorized as one of four different types. The first category is warm natural light. Typically a rising or setting sun, as in *Kipling Woods*, provides warm light. The second category is cool natural light. Overcast skies and daylight at noon, when the sun turns a greenish yellow, are cool natural lights. The third category is warm manmade light. Light bulbs (incandescent bulbs) typically produce a warm light. The last category is cool manmade light. Regular fluorescent bulbs produce a cool, blue-green light.

How to Use the Color Wheel

If the light source is warm, then the color of all the objects in the scene will become warmer as they come to light. If the light source is cool, all the colors become cooler as they come to light. To visualize these changes, take a color wheel and turn it so the color of your light source is at the top of the wheel. With the color wheel in this position, as each color comes to light it not only changes in value, becoming lighter, it also shifts to the hue above itself on the color wheel. As it goes to shadow, it becomes darker in value and shifts to the hue below itself on the color wheel. In the painting *Soda Tree* the light source (the sun) was orange-yellow; I rotated the color wheel so orange-yellow was on top. With the color wheel in that position, the green of the

tree shifted to yellow-green as it approached the light. It shifted to blue-green as it went into the shadow. The grass, which was a dried-up orange, shifted to a yellow-orange as it came to light. For any source of light, simply rotate the color wheel so that the color of the light source is on top. After a while, you won't need the color wheel anymore. You will be able to visualize it in your mind.

Warm Natural Light

Morning and evening sunlight passes through more miles of atmosphere than does noon daylight. This additional air filters out the green and blue light, leaving the sun looking red to orange-yellow. The sun continues to be quite warm for several hours after sunrise and gradually warms up again an hour or so before sunset. As the sun approaches noon it becomes cooler in color, turning yellow, then yellow-green.

When the sun is out, there are actually two sources of light illuminating the scene, the intense light of the sun and the weaker light of the blue sky. Early morning or late evening sunlight is characterized as much by the absence of green in the sunlight areas as by the red to orange-yellow quality of the light. Most of the green and blue sunlight has been filtered out by the air, leaving little cool light for green objects to reflect.

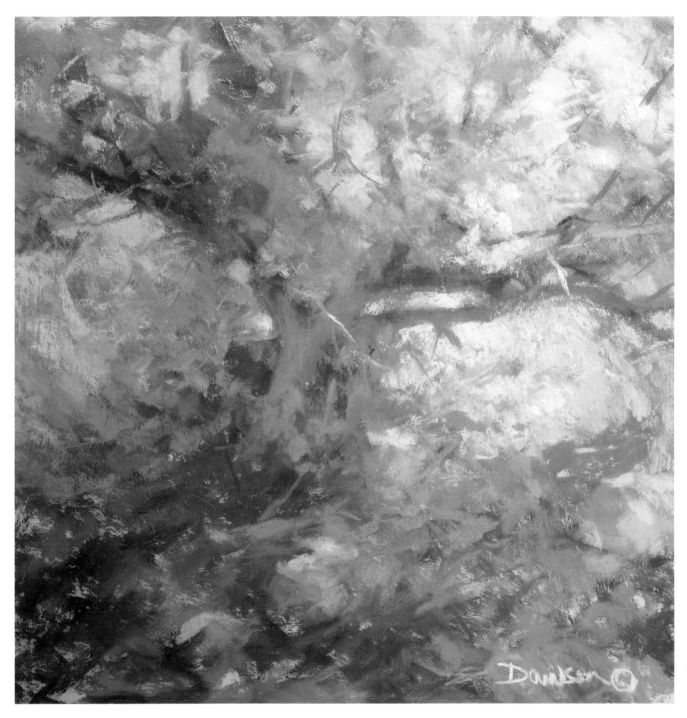

▲ **"Soda Tree"** *16″ × 16″*
Private collection
In *Soda Tree* I used green sparingly and then only in the halftones and shadows. I painted the sunlit parts of the tree dull yellows and oranges, reflecting the shift in color as the green came to light. In the halftones I used a dull yellow-green in combination with a dull orange, making the halftone green even duller. The halftones are illuminated by roughly equal amounts of reflected sunlight and blue-sky light. I used some green, blue and violet in the shadows. Here the tree and grass are illuminated by the blue light of the sky. The contrast between the cool colors in the shadows and warm colors in the sunlit areas intensifies the feeling of warm morning light.

▲ Rotation of the color wheel with yellow-green on top.

Cool Natural Light

Midday sun and overcast skies produce cool natural light. The sun gradually changes from warm to cool light as it approaches noon. In *Diane by the Window*, the angle of the sunlight indicates the time of day was about 10:30 in the morning. At this time of day, it is not always easy to determine if the light source is warm or cool. Sometimes the color of the shadows is a better clue than the color of the reflected light, which can look very nondescript. I usually try to look at the shadows on something white. I compare the light on the white object to the shadows. If the shadows look blue or green, I know the light source is warm. If the shadows look brown or red-violet, I know the light source is cool in color. The eye tends to fill in the shadows with the color that is complementary to the light source. (This test is not as reliable outside where the shadows are filled in with blue-sky light.) If there is nothing white to look at I look for a solid-colored object that is in the light. In *Diane by the Window* there were no white objects. The door behind Diane was a solid burnt sienna color in the shadows. It lost its reddish color in the lights, becoming a dull ocher. The loss of the red color in the door indicated that the light was complementary to the red and had green properties, probably a greenish yellow. I imagined the color wheel rotated so greenish yellow was on top.

▶ **"Diane by the Window"** 38½″x31½″
Collection of Mr. and Mrs. R. Zinke
There was a much greater range of values in this scene than the ten values I can achieve with pastel. I decided I would either have to sacrifice the figure, making it just a dark silhouette, if I wanted to show anything outside the window; or I would have to sacrifice what was outside, treating it as just a source of bright light, if I wanted to show anything in the model.

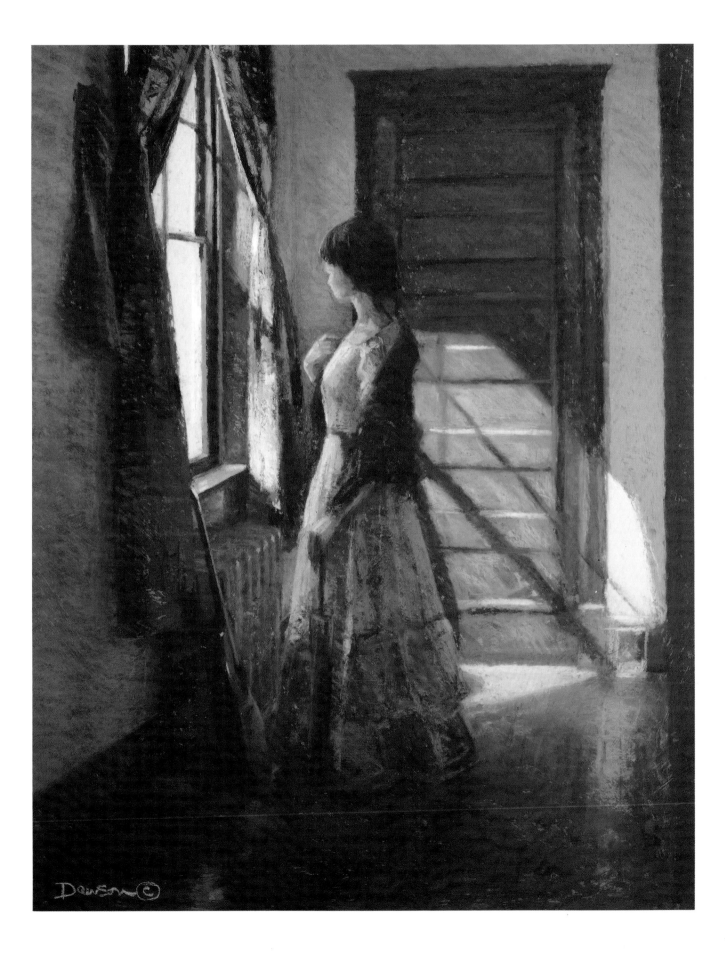

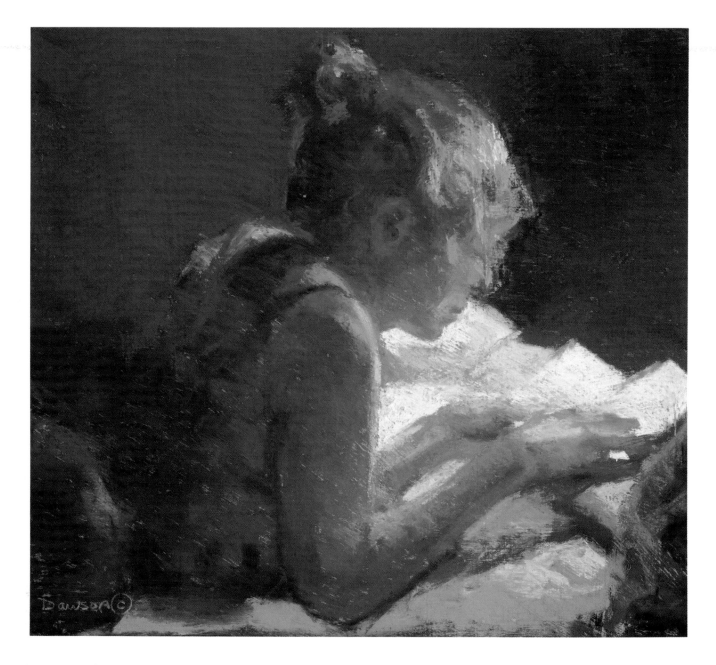

Warm Indoor Light

Regular light bulbs (incandescent lights) are the usual source of warm indoor light. *Sue by the Reading Light* is a painting of my wife reading under a bed lamp. The sixty-watt bulb in that lamp produced a warm yellow-orange light. Imagining the color wheel turned so yellow-orange is on top, I painted the color of her skin a yellow-orange in the lights and a dull red-violet in the shadows. Outside, the blue light of the sky fills in the shadows, causing them to look even cooler. Inside, there is no secondary source of cool light. The light in the shadows is light from the lamp reflecting off the walls of the room. The shadows are

cooler than the light, but not as dramatically cool as they would be outside. The most intense color in the painting is in the halftones. *Regardless of the light source, indoors or out, the most intense color is often in the halftones that separate light and shadow.* Note that greens and blues are absent from this painting.

Cool Indoor Light

Fluorescent lights are generally cool. In the painting *Mile Hi Liquors* the inside of the liquor store is illuminated by fluorescent fixtures, causing the store to glow with a blue-green light and causing blue light to spill out onto

▲ **"Sue by the Reading Light"** 15″ × 16″
Collection of Mr. and Mrs. James D. Parks
The warm yellow-orange of the light bathes the figure in these colors.

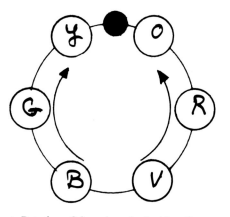

▲ Rotation of the color wheel with yellow-orange on top.

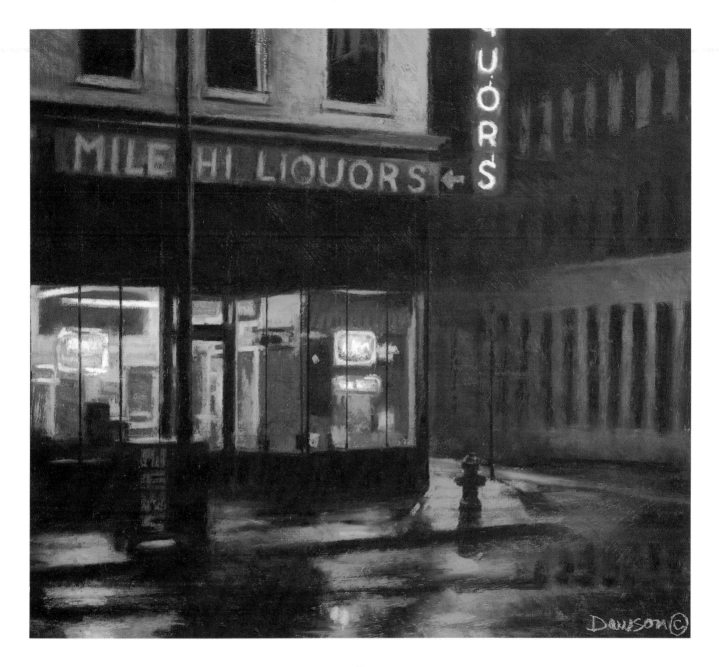

the sidewalk. I imagined the color wheel rotated so that blue-green was on top. The beige wall inside the store looked blue-green where the lights shone on them. They looked warmer, a dull yellow-green, in the shadows.

Besides the cool fluorescent lights, there were several neon signs. Don't confuse these with fluorescent fixtures. Neon bulbs come in a number of intense warm and cool colors. They produce a very narrow spectrum of light. The ones in this scene were bright red. That red light reflected on the outside of the building and the trim around the window. In these places, the objects get redder as they come to light.

▲ Rotation of the color wheel with blue-green on top.

▲ **"Mile Hi Liquors"** 24″ × 26½″
Collection of Robert F. Messman
In *Mile Hi Liquors* the inside of the liquor store is illuminated by fluorescent fixtures causing the store to glow with a blue-green light, and causing blue light to spill out onto the sidewalk.

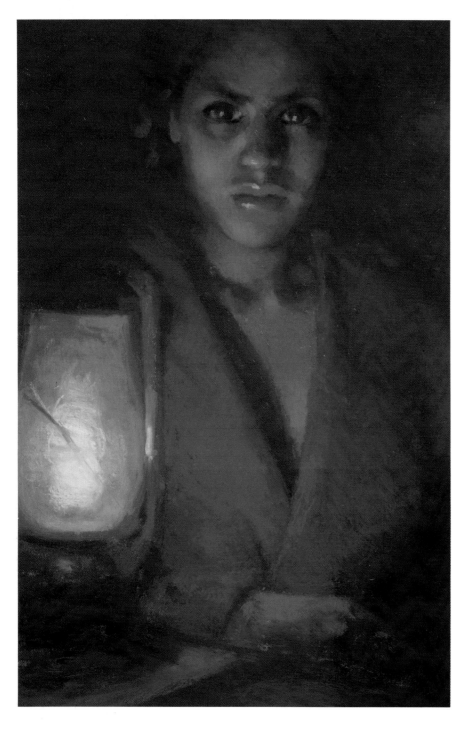

◀ **"Loris by Lantern Light"** 24″ × 16″
Private collection
Candles and other open flames produce very
orange light, which was what I was trying to
capture in this painting.

▶ **"Carriage on Lawrence"** 14″ × 16″
Collection of Ralph and Elly Schaefer
Look for halos when painting lights. They are
always there, sometimes nothing more than a
thin soft edge between the light and the back-
ground and sometimes as large as in *Carriage
on Lawrence*.

Glowing Light

In *Loris by Lantern Light*, I wanted the
lantern to glow with light. To give the
illusion that a light is glowing it must
be placed next to values at least four
or five steps darker. To complicate the
problem, there is no way light reflect-
ing off white in the painting can be as
light as the light radiating from a lan-
tern. My lightest value would have to
be darker than what I really saw, and
in turn, each successive value would
have to be darker if the value relation-
ships were to be the same. To make
the lantern look like it was glowing, I
needed to keep all the other values in
the painting as dark proportionally as
the values around the real lantern. As
a consequence, I painted Loris's face
and the other shapes in the painting
darker than they seemed in order to
give the illusion of a glowing light. I
had a choice; I could have painted
Loris the way she appeared and sacri-
ficed the feeling of light, or I could
have painted the light the way it ap-
peared and sacrificed Loris to the
shadows. I chose the latter. A common
mistake is to *not* make a choice, which
is analogous to not thinking about
what you are trying to say. I chose to
sacrifice clarity in the figure for the
glow that I wanted in the light.

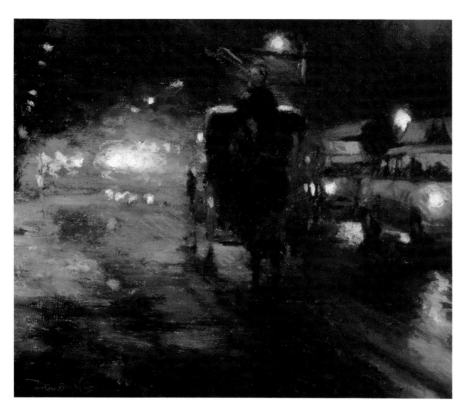

▲ When painting an incandescent light such as the headlamp of a car, I first paint in the shape of the light with orange.

▲ Then I bring in the dark values that indicate the surrounding atmosphere to just cover the edges of the light.

▲ My next step is to fill in the shape of the light with a yellow or yellow-orange a little darker in value than the brightest value will be.

▲ Finally, I paint a very light value of yellow or white over the yellow, leaving an edge of the yellow-orange visible that is in turn surrounded by orange.

Painting Lights at Night

Incandescent bulbs give off a yellow to yellow-orange light. Car headlights produce a yellow color, while regular light bulbs produce more of a yellow-orange color. These bulbs are brightest and yellowest in the center where the filament is. As you move out from the center and approach the edge of the bulb, the color becomes more orange. Surrounding the bulb, the air and the light fixture reflect light that is oranger yet.

I call this edge that surrounds the light the halo. All lights are surrounded by halos. The halo is partly a result of the shift in color temperature from the center of the bulb out, as I have already described. It is also the result of reflections of light off the fixture, close objects, rain, snow, fog or smoke. On a rainy or snowy night, there is always a large halo of light surrounding street lamps. The halo surrounding a cool light, such as a fluorescent fixture, is generally bluer than the center of the light. The halo surrounding a warm light is generally redder than the center of the light.

I took advantage of this phenomenon in *Carriage on Lawrence*. The whole background behind the carriage is one big halo of light caused by the approaching cars. There are smaller halos surrounding the closest street lamp and the headlight of the closest car. Look for halos when painting lights. They are always there, sometimes nothing more than a thin soft edge between the light and the background and sometimes as large as in *Carriage on Lawrence*.

Nighttime Value Scale

At night, the value scale outside is skewed to the lights and darks. There are almost no middle values. Everything the eye sees is dark or light. Outside during the day the middle values are the shapes illuminated by the blue of the sky. Inside, day or night, the middle values are those shapes illuminated by light reflecting off walls and other close objects. In either case, the dark shadows are those places not reached by either reflected light or secondary light. Outdoors at night there is no secondary light (blue sky) and very little reflected light to fill in the shadows. Therefore everything is either light in value because it is in direct light or dark in value because it is in the shadows. In the painting *Cafe du Monde*, most of the painting is dark. The streetlights and the cafe window stand out in stark contrast. The only middle values are small transitional shapes between the light and dark. This strong contrast between the light and dark gives the illusion that the lights are glowing and that it is night. Before I learned this lesson, I had a number of paintings fail because I included too many middle values.

At low light levels the color-sensitive cells in your eyes turn off. You lose your color vision and are forced to rely upon your black-and-white vision. The result is that at night colors are dull and nondescript. In *Cafe du Monde* I avoided using intense dark colors in the shadows, preferring dull cool colors (grays) and dull warm colors (browns) instead. I used intense color only in the lightest values and in the small transitional halftones.

▶ **"Cafe du Monde"** 33″ × 37″
Collection of Valhalla Gallery, Dallas, Texas
At low levels of light you lose your color vision, so colors become dull and nondescript. In *Cafe du Monde* I used cool grays and warm browns to bring the night light to life.

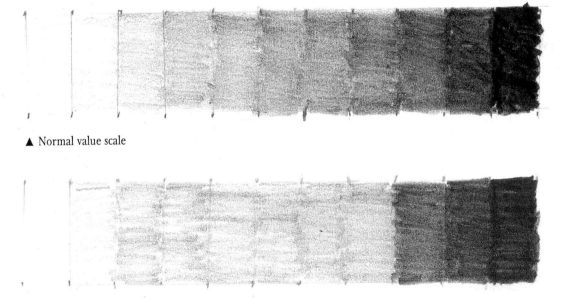

▲ Normal value scale

▲ Nighttime (skewed) value scale

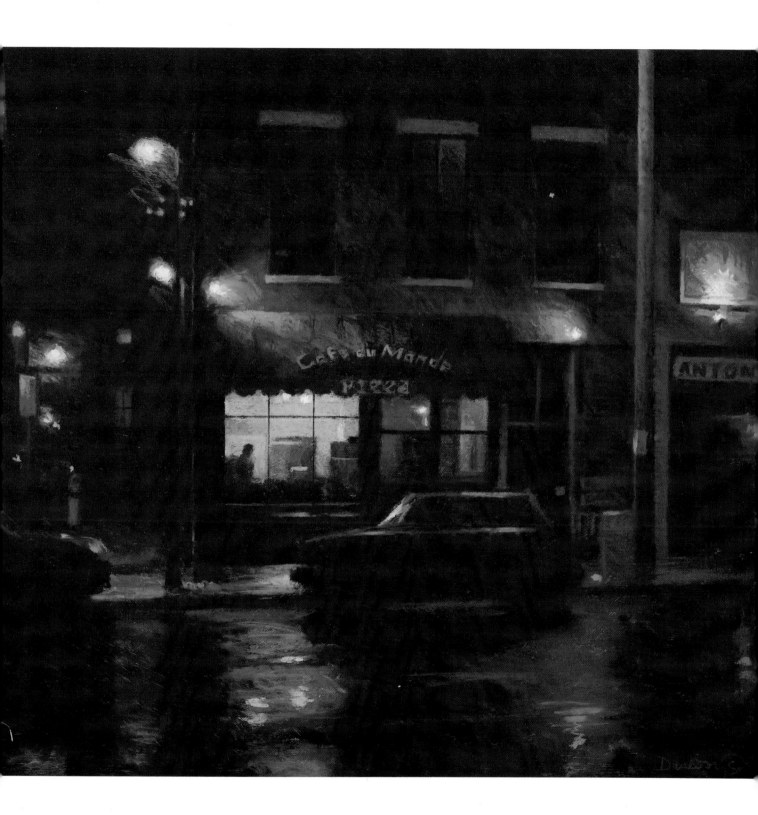

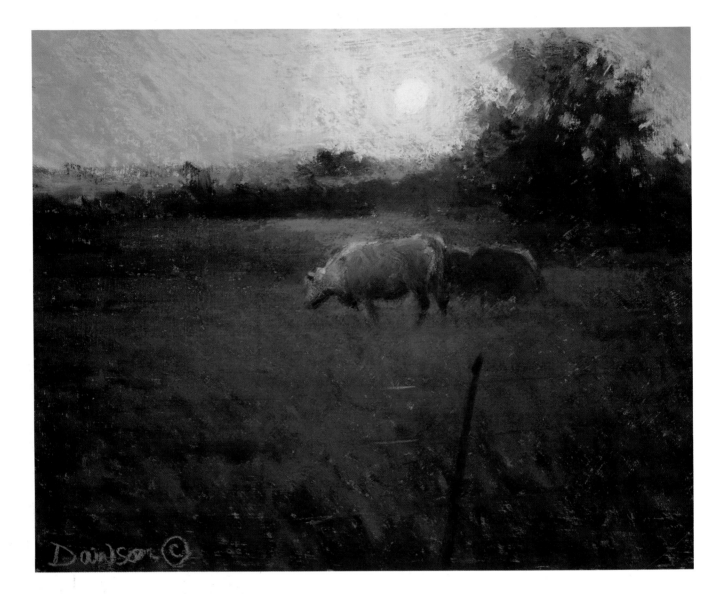

▲ **"Study of Sunset"** 14½″ × 18″
Collection of Kent and Veerle Ullberg
My interest in painting the actual light source started when I painted *Study of Sunset*. I was fascinated by the way the edges of the trees and distant hills got lighter in value and warmer in color the closer they got to the sun. At the closest point the edges softened and disappeared as if the sun had taken a bite out of them.

Edges

When you look directly at a source of light such as the setting sun, the edges of objects directly in front of the light source and objects near the light source such as trees soften and disappear. This happens because these objects reflect so much light that they are nearly as bright as the light source itself. As the brightness of the reflected light approaches that of the light source, shapes get lighter in value and warmer in color, causing the edges to soften and disappear. I find this phenomenon so visually interesting that I often go out looking for it.

Combining Warm and Cool Light

It is a good idea to avoid combining two different light sources in the same painting, especially if one is warm and the other cool and they are of equal strength. In mixed light, some shapes will become warmer in color as they come to light and some will become cooler. Further, there will be cool highlights on some objects and warm highlights on others. The result is visual confusion. An example of a situation to avoid would be a model sitting under an incandescent light and next to a window. The model would have a

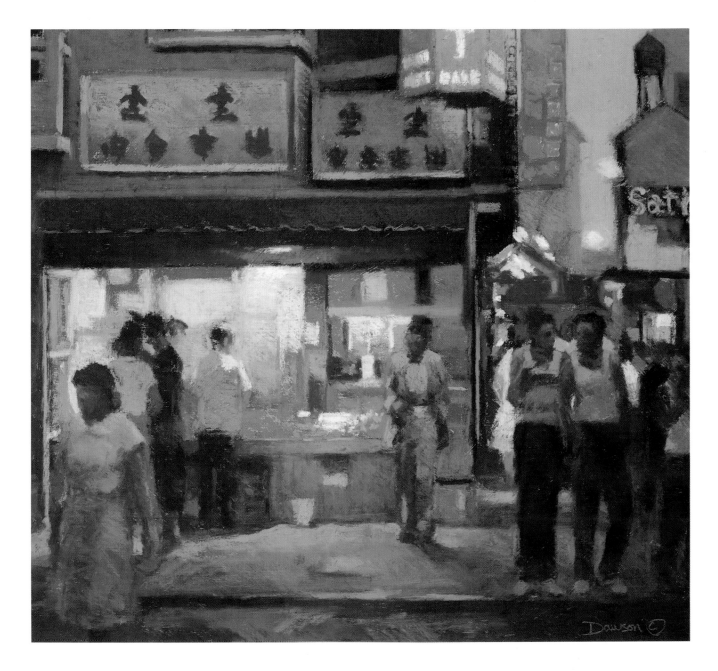

warm source of light on one side (the light bulb side) and a cool source of light on the other (the afternoon sky). It would be better to either cover the window or turn the light off so there would be just one source of light. There are a few exceptions to this rule. These are: where two sources of light are unavoidable, and where two sources of light contribute to the mood of the painting. *Night Market* is such an exception. The sun had just set and the sky was filled with blue-violet light.

This cool light was illuminating the outside of the building and some of the closest figures. The store, however, was lighted with warm incandescent light. The people standing closest to the storefront were seen in this light. The combination of light was important to the mood of the painting, as it was typical of what one experiences in a city at this time in the evening. The mixed light was understandable in the context of the scene.

▲ **"Night Market"** 20″ × 22″
Collection of Al Hogan
Night Market is an example of a painting using two separate light sources. The light from the store mixing for a short time with the evening light is typical of what you might experience in the city at this time of day.

Painting Water

It is no wonder that water fascinates us. Water is one of God's great kaleidoscopes, made up as it is of many small reflective shapes that are constantly moving. I know that if I lived near the coast I would spend much of my time painting the ocean. Living in Colorado, I still find opportunities to paint mountain streams, lakes, and wet city streets. The very properties that make water fascinating, the fact that it is reflective and moving, also make it confusing. The best way to overcome this confusion is to study the predictable properties of water.

▶ **"Cataract Below Berthoud"** 20″ × 24″
Collection of Mr. and Mrs. W. Lee

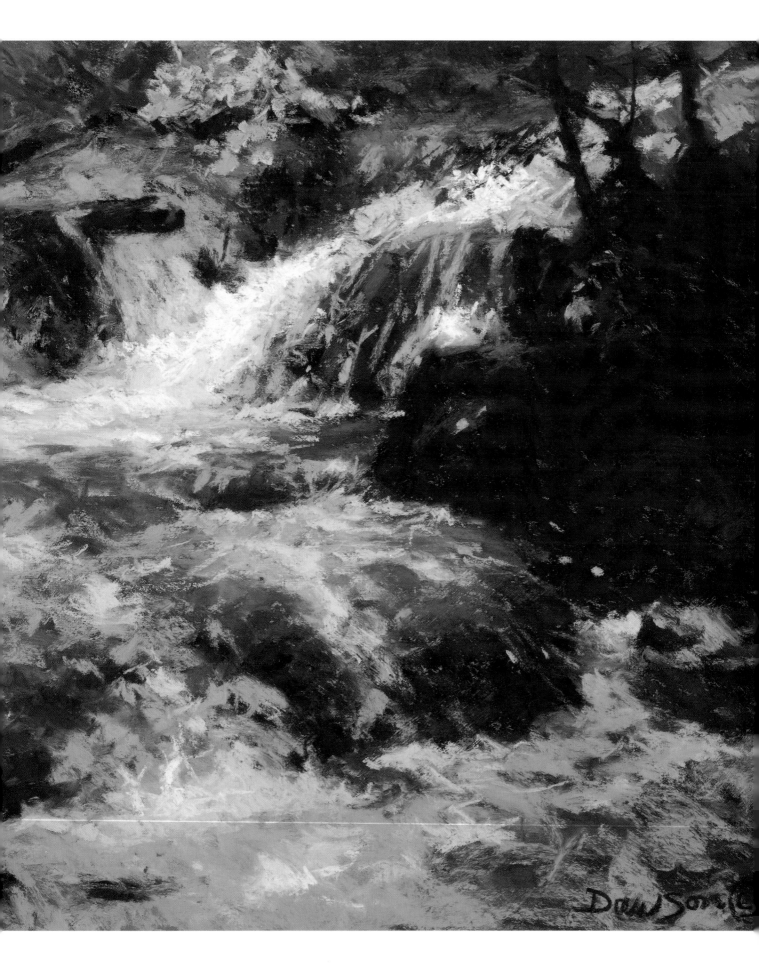

The Three Layers of Water

When we look at water we may see as many as three overlapping layers. The top layer includes everything floating on the surface, such as foam, boats, lily pads and so on. The middle layer is the surface of the water itself. If nothing is floating on the water this may be the only visible layer. The bottom layer is anything under the surface of the water, such as fish or the bottom of the lake. In most situations, the bottom layer is not visible and we don't have to worry about it.

Visualize the middle layer as if it were a broken mirror, made up of many small, flat reflective surfaces. The arrangement of these reflective surfaces is determined by the shape of the waves and the wave patterns. A simple wave is made up of two reflective shapes, the front of the wave and the back of the wave. If the wave is rolling in toward you, the front part behaves like a mirror tilted toward you. It will reflect the sky above or to your back. The back of the wave behaves like a mirror tilted away from you and reflects the sky or objects in back of it.

While the bottom layer is usually not visible, when it is seen, it should be blocked in first. After the bottom layer is blocked in, paint the light reflections of the middle layer. In this way, the middle-layer shapes will overlap the bottom-layer shapes, mimicking the way the light reflections on the water overlap the objects underneath.

▶ In order to simplify this complex subject matter and paint water more easily, it is helpful to think of water as having three planes.

Boat on top layer of water

The surface of the water ——————

Rocks under the water

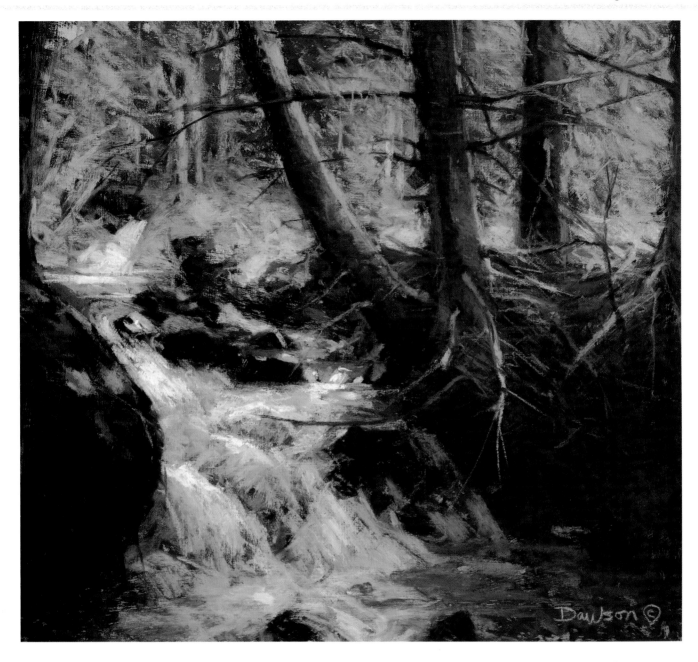

Painting Planes in Water

In Chapter Twelve I discussed the importance of separating space into planes to create the illusion of depth. Water also must be divided into planes. The foreground plane in water is usually that space where the shapes of waves are clearly visible. The background plane is that space where the waves are too small to paint individually, where they must be represented as pattern or textures on the water. The middle ground, if there is one, is the transition between these two. If a painting includes land and water, the planes of the water should be aligned with the planes of the land. The painting *Below Berthoud* has a simple foreground and background. The line that separates the land into foreground and background cuts across the water at the top of the falls and divides the water into foreground and background as well. I painted the water above the line in simple linear shapes that imitate the pattern of groups of waves above the falls. Below the line I painted the individual wave shapes tumbling over the rocks.

▲ **"Below Berthoud"** 24″ × 26½″
Private collection
Foam on the surface of water is usually lighter in value than anything reflecting on the middle layer short of the sun. This is because foam is made up of little bubbles, each of which reflects points of light. Don't confuse it with the light sky reflections of the middle layer. It can't reflect objects the way the middle layer can. Because it rides above the water like whipped cream it has a light side and a shadow side, and shadows may be visible on it. Foam is typically present where waves break on a beach or where water tumbles over falls.

The Three Zones of Reflection

There are three zones of reflection evident when you study the reflections of objects in the water. Each zone is identified by the characteristic pattern of reflection of its waves. All three patterns are evident in the painting *Checking the Nets*. Closest to the boat, both sides of the waves reflect the boat. Since the boat is dark, I painted this zone dark. The absence of sky reflections characterize this zone. Surrounding this space is a second zone. In this region the front side of the wave reflects the sky and the back side of the wave reflects the boat. This zone is typically broken up with a light and dark pattern. The last zone is made up of waves that reflect the sky on both sides. I painted this zone with slight color variations because the sky varies in color and each side of the wave reflects a different region of the sky. This third zone may be penetrated by the reflections of tall objects such as the masts of boats. All three of these zones may be present, as in *Checking the Nets*, or just the second and third zones may be present, or just the third alone. Which ones are present depends upon the size and shape of the waves and upon how close your eyes are to the surface of the water.

Water has color; therefore, it reflects like a toned mirror, causing light objects to appear darker than they actually are. In *Checking the Nets*, I painted the reflection of the sky several values darker than the sky. Similarly, the reflections of dark objects

▲ **"Checking the Nets"** 13″ × 14½″
Collection of Susan Robinson
The three "zones of reflection" are evident in this painting. However, when you paint objects on water be careful not to confuse shadows with reflections. Shadows always fall away from the light source, whereas reflections always come toward you, regardless of the light source.

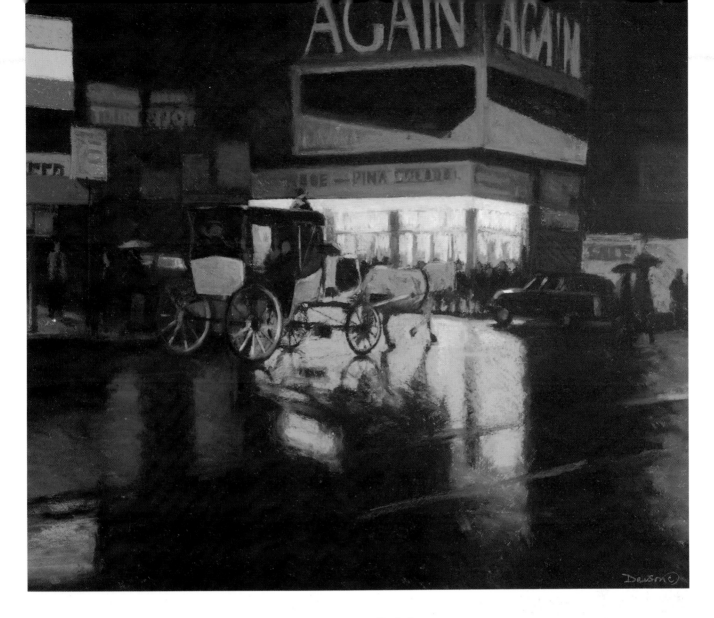

such as the side of the boat are a value or so lighter. This happens because the dark reflections get broken up with small spots of sky light reflecting off the water. The eye interprets this mixture of light and dark as a slightly lighter value.

Don't confuse shadows with reflections. Shadows may be visible on water. It depends upon the lighting conditions and how clear the water is. Shadows always fall away from the source of light. If the light is to the right, the shadow will fall across the water to the left. On the other hand, reflections like those of the mast always come toward you, regardless of the light source. In *Checking the Nets*, my vantage point is front and center. Therefore, any reflection should angle toward the bottom middle.

Painting Rain-soaked Streets

There are two types of reflections that occur on rain-soaked surfaces such as streets. Where there are puddles of standing water, the street will reflect recognizable objects like a mirror. The brightest reflections of light are off these puddles. Where the street is wet but not water-covered, the reflections are matte and dull. These wet areas will reflect patterns of light and dark but not understandable images. In the painting *Hansom Cab*, I painted recognizable reflections of the blue window light, the horse's legs and the carriage wheels because they were reflected off the standing water. I painted the reflected blue window light a value darker than the light itself. In other places, I kept the reflections dull and nondescript.

▲ **"Hansom Cab"** 30″ × 34″
Collection of Dr. and Mrs. Stewart Lonky
In *Hansom Cab* I painted recognizable reflections of the blue window light, the horse's legs and the carriage wheels because they were reflected off standing water. I painted the reflected blue window light a value darker than the light itself. In other places, I kept the reflections dull and nondescript. These are the parts that were wet but not water covered. Tire marks are visible in the foreground. The wheels of a passing car had squeegeed the street clear of water as it passed. I painted the tire marks as if they were dry pavement.

▲ **"The Music Store"** *20″ × 20″*
Collection of Fred and Patty Turner
In *The Music Store* the street was wet, but there
was hardly any standing water. None of the
objects in the painting are visible in the reflec-
tions on the street. I broke up the reflected
window light into small spots of bright light
surrounded by duller, darker areas. I did the
same with the light reflected from the bus's
headlights. Where the reflections of the head-
lights are the brightest, I assumed there was
a little puddle of water. I kept most of the
reflections dull.

Painting Wave Patterns

Painting water is like trying to paint a horse as it runs by. With one horse, the task seems impossible, but if horses ran by one after another all day long, with each passing horse you could make another observation and another addition to the painting. Water is constantly moving, yet certain patterns repeat themselves. The pattern of waves rolling in on a beach repeat, not with every wave, but sometimes with every third, or fourth, or seventh wave. Boats and birds moving through the water cause wake patterns. Rocks and other obstacles cause patterns as water rushes over them or rolls against them. When you are painting water, look for the big repetitive patterns, the big shapes. Don't get caught up in the detail of one little wave or reflection. You may catch a scale and lose the fish.

Just as a knowledge of horse anatomy would help you paint that imaginary horse as it runs by, so a knowledge of water will help you sort out new water problems as you encounter them. Study photographs of the different types of water problems. Study the patterns of waves and the patterns of reflection. Look for the ways in which water repeats itself.

▲ **"Below the Falls"** 19″ × 23″
Collection of Michael R. Bieber, Ph.D.
In the painting *Below the Falls*, my first concern was with the larger shape of the water as it tumbled over the falls with its pattern of dark holes caused by rocks or logs. Second, I separated the large shape of the water into the shape of the tumbling water and the shape of the spray. The tumbling water behaves like a wave reflecting the sky and other objects. The spray, on the other hand, is made up of small water droplets and behaves like froth or foam. It doesn't reflect the sky or other objects but may reflect shadows falling across it. The spray is the lightest value in the painting. Below the falls, the falling water caused a pattern of concentric, radiating waves on the pond.

Painting Snow

I love snow because of the way it reflects light and breaks the land up into powerful light and dark patterns. On snowy days, I hike around looking for strong patterns of light and dark with which I can design a painting. I prefer light snows to heavy snows, because light snow often leaves open patches of grass and rocks. Heavy snow covers everything. One of the best times to go out is when the snow has started to melt off. The melting process exposes the ground and creates interesting interlocking patches of snow and earth. Not insignificant is the fact that when the snow is melting, the weather is warmer and more comfortable to work in.

When the snow is heavy, I avoid the flat places and look for streams or rough terrain. Heavy snow on rough terrain has interesting shadow patterns, because the snow echoes the irregular contours of the ground underneath. The sides of rocks and fallen tree trunks may remain exposed, breaking up the snow with small, irregular dark shapes. And over an open stream the snow melts away, leaving water and ground visible.

▶ **"Fall River"** 24″ × 26″
Corporate collection

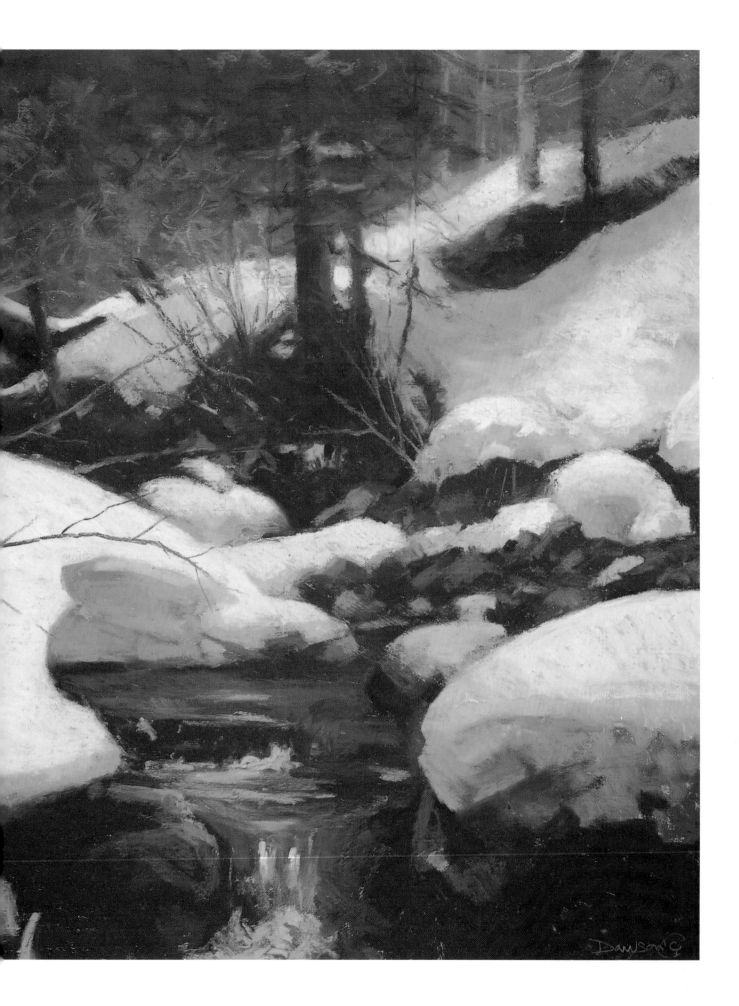

Avoid White

Avoid white. Try to create the illusion of white without using white. In *Fall River* (previous page), I used a light raw umber in combination with a light blue for the lighter values. I used white only to accent the lightest shapes in the distant foreground. In most snow paintings, I never use white at all.

The Color of Light on Snow

Because snow is white, it reflects the color of the sun in the lights and the color of the sky in the shadows. At sunrise or sunset, the light reflected by the snow is pink or orange. Shortly after sunrise it turns yellow-orange. Later in the morning it becomes yellow and, eventually, yellow-green about noon. The process reverses itself as the day goes on from noon to sunset.

Complicating the observation that snow reflects the color of the sun in the lights and the color of the sky in the shadows is the fact that these reflected colors become cooler as they go back in space. This color shift must be exaggerated to make it work. Lights shift from yellow to orange to red as they are successively filtered out by the air. See Chapter Twelve for more information on color shifts and why they happen.

▼ **"Nederland Country"** 20″ × 22″
Collection of Therese L. Faget
Nederland Country was done at about ten in the morning. The sun was yellow, therefore I painted the light in the foreground yellow. To make the light on the background snow cooler I painted it yellow-orange. If the foreground light had been orange, as it is might be right after sunrise, I would have painted it red-orange in the background.

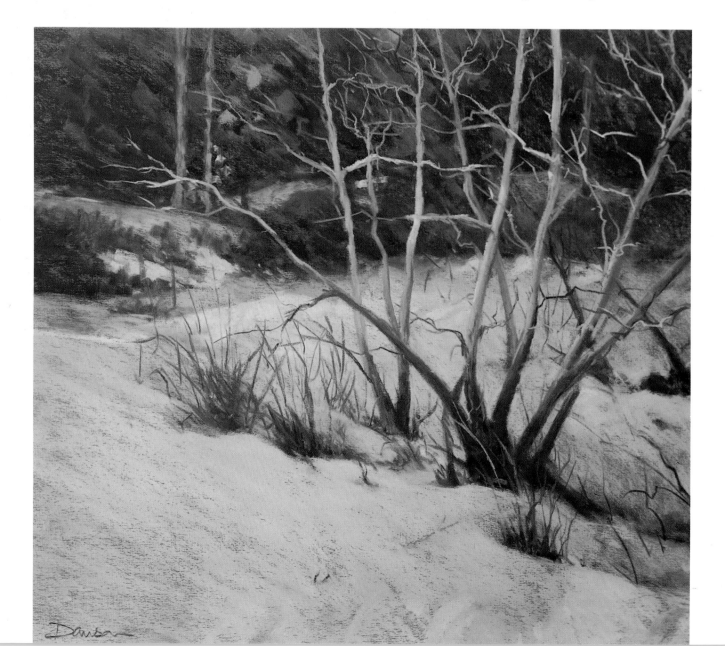

Dawson

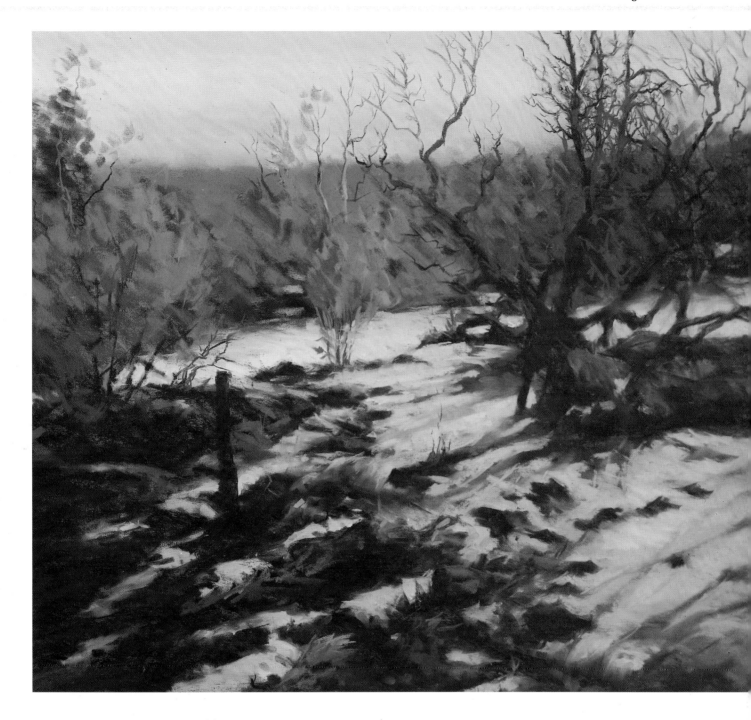

The Color of Shadow on Snow

The principle that colors get cooler as space recedes holds true for shadows as well as for lights. An important difference is that shadows reflect the light of the sky, usually blue-green, blue-violet, or blue; therefore, they are already cool. Shadow colors shift from blue-green to blue-violet to blue as space recedes because first the yellow is filtered out by the air, then the oranges, then the reds. If shadows are blue in the foreground, lacking any green or violet properties, they remain blue in the background. Remember, however, that the sky changes color from overhead to horizon and from one region to another. If these changes are dramatic, you can expect similarly dramatic changes to occur in the shadows on the snow. The snow will reflect the different regions of the sky depending upon its angle relative to the sky.

▲ **"Hoarfrost in Coal Creek"** 27½″ × 29½″
Corporate collection
When I painted *Hoarfrost in Coal Creek*, the sky was green-blue near the horizon (behind me) and blue overhead. I used both of these colors in the foreground shadows. In the background, I eliminated the blue-green and just used the blue.

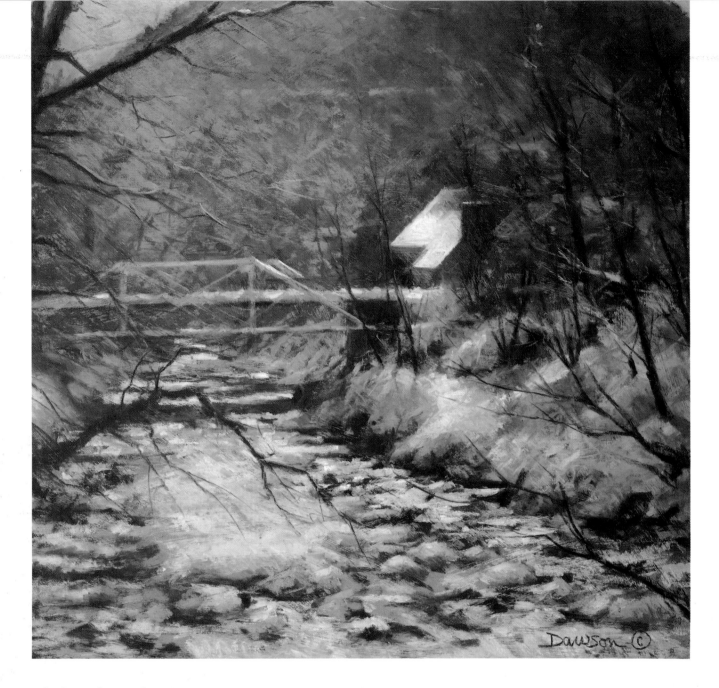

Block In the Darks First

Avoid setting up a painting in such a way that it forces you to paint dark over light. *Working dark over light is a recipe for muddy color.* The greater the value differences, the greater the likelihood of mud. Since snow is so light, the risk of muddy color is great.

In *Upper Bear Creek* I knew that the snow and water were going to be broken up into many small shapes by the many rocks and small areas of open ground. This brokenness, the strong contrast between these small shapes, was an important part of what I wanted to say in the painting. I knew that if I blocked in the snow first, I would paint some of the snow shapes in the wrong position and would have to work over them with dark shapes, resulting in muddy color. An option would have been to draw the whole thing out and use the lines to organize it. I rejected this because I wanted to leave evidence in the painting of the excitement I experienced when I organized it with shapes. I decided to block in the darks first and then work around them with the lights. I blocked in a rough impression of the background, mountain, and trees as well as the many small, dark rock shapes, the underside of the bridge, the tree branches, and open areas of ground.

▲ **"Upper Bear Creek"** 33″ × 33″
Collection of Joe Branney
In *Upper Bear Creek* I decided to block in the darks first and then work around them with the lights in order to avoid getting a lot of muddy color from working darks over lights. I blocked in a rough impression of the background, mountain, and trees as well as the many small, dark rock shapes, the underside of the bridge, the tree branches, and open areas of ground. When I was happy with the arrangement of the darks, I blocked in the shadow values of the snow, then finally the lights.

When I was happy with the arrangement of the darks, I blocked in the shadow values of the snow, then finally the lights.

Getting the Edges Right

Edges are a special problem in a snow painting, for reasons I have already alluded to. It is often necessary to overlap a background snow shape with the upper edge of a darker vegetation shape in front. The overlap is necessary because it mimics the overlapping of edges in nature and gives the illusion that one shape is in front of the other. This necessarily results in darks over lights and can cause muddy color. Multiple strokes over a light color especially stir up the color and cause everything to get muddy. The trick is to anticipate the overlap and reduce it as much as possible.

After overlapping the necessary edges, the last step in painting *Firewood Gulch* was to paint in the thin shapes of individual plants in the foreground. I painted these directly over the snow. I used single heavy strokes of pastel so there was less danger of stirring up the mud.

▼ **"Firewood Gulch"** 24″ × 36″
Collection of Gertrude Spratlen
In the painting *Firewood Gulch*, I first blocked in the darker shapes of exposed ground as well as the other small dark shapes in the painting. As I did, I painted the upper edges of these shapes the way I visualized them in the finished painting. I then painted the light values of snow in around them so its edges would overlap the darks in the finished piece. On top, however, the vegetation should overlap the snow. I painted snow down to and just slightly overlapping the top of the vegetation. Then I repainted the top of the vegetation, so its edges overlapped the snow. In this way, I got the overlap I wanted without stirring up a lot of light pastel with the overlapping dark.

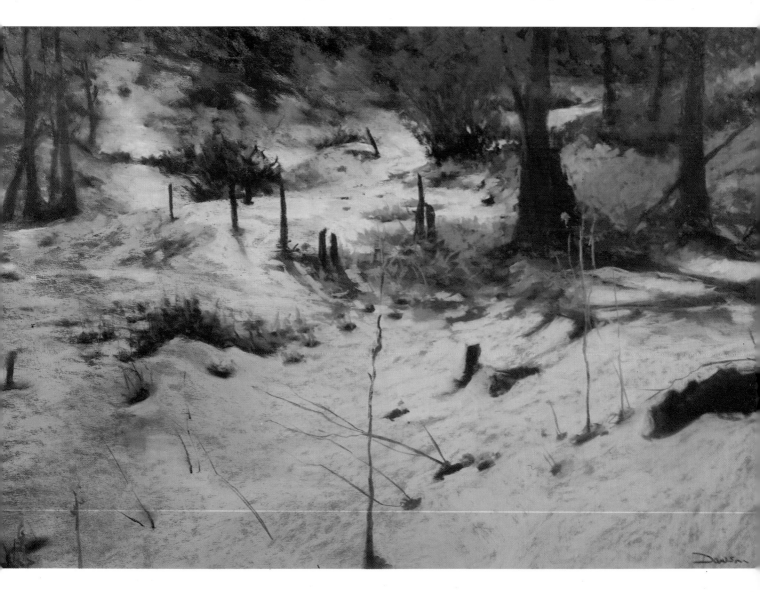

How to Find New Ideas

Creative ideas either result from combining two or more older ideas (I call this an *idea attachment*) or they are a variation on an existing idea. For example, the banjo was invented by Africans who had seen and wanted to make a guitar. They didn't know how to make the head for a guitar, but they knew how to make a drum. They combined the two ideas. The result was an idea attachment, a guitar-drum, what we call a banjo.

There are two different types of banjos, the four-string banjo and the five-string. One of these was invented first. The second was a variation on the banjo theme. It resulted from someone playing with the idea of a banjo, trying to make it a different way, in this case by adding a string and changing the tuning. Everything new results from one of these two approaches or a combination of them.

▲ **"Botinelly's Daughter"** 15″ × 14″
Collection of W. Cohen

Search Through History

For the artist, one of the best ways to create something new is to search the past, looking for ideas to borrow. This borrowed art can be combined with other ideas from the past or present or with the artist's own ideas. I visualize the field of art as a pool, filled with all the art that has ever been done. Anyone who wishes can reach in and borrow any ideas, materials, techniques or methods he wishes. In turn, everything you or I create gets added to the pool for others to borrow.

The painting *Miss Botinelly* is an example of combining some ideas from the past with my own ideas. I was inspired by some portraits done in the fifteenth century. In particular I was intrigued by the composition of some of these portraits, which usually included the face and hand and generally looked as though the model were standing before a small window. I also found the old northern European style of dress intriguing. Fifteenth-century compositions continue to fascinate me and I still look for opportunities to explore them.

▲ **"Miss Botinelly"** 22½″ × 17¾″
Collection of the First Interstate Bank of Denver
The painting *Miss Botinelly* is an example of combining some ideas from the past with my own ideas. I tried to imitate the style of dress by improvising with lace and pieces of cloth and clothing. I did this within the structure of these fifteenth-century compositions.

▶ **"Paula in Pink"** 12″ × 12″
Collection of Kent and Veerle Ullberg
Using acrylics, I toned a Masonite board a dull violet. Then I leafed the board with imitation silver leaf. I applied a gel medium/pumice mixture just to the areas where I was going to use pastel, because I had discovered that the gel destroyed the shine of the leaf. To keep it from looking too metallic, I antiqued the leaf with some blue-green and violet acrylic washes. I blocked in the shapes where the pastel would be with the acrylic gel/pumice mixture.

Borrow Techniques from the Past
Look for interesting techniques or materials used in the past but ignored today. For one thing, it is easier to make a name for yourself with materials and media that few people are using. Pastel wasn't attracting much attention when I started working with it. There are more pastelists now but we are still not as numerous as oil painters and watercolorists. Other media that are presently overlooked but are worth considering include encaustics (painting with hot wax) and fresco. Of course, there are others. Search the history books. Look for techniques that are exciting but not in use today. One material that I liked but that was getting very little use was gold leaf, which was used in a lot of religious art in the Middle Ages. It took some experimentation to find a way to use pastel with the slick gold or silver leaf. The result was *Paula in Pink*. I've just begun to work with this idea and I think it is worth pursuing.

Themes from the Past
Some of the best new ideas are variations on old ones. Some themes from the past that could be explored in a contemporary way are mythology, religion, war, storytelling, events such as weddings and funerals. This list is far from complete.

Religious themes have been largely ignored over the past one hundred years because the great patron of religious paintings, the Catholic church, went out of the art business. There probably isn't much of a market for religious paintings either. Few people are likely to hang one over their mantel. This brings me ultimately to the question of why I am an artist. If the reason is to make money, there are many easier ways to do it. I am interested in religious themes, both because they have been ignored and because they are an important part of who I

am and what I would like to express as an artist. *Joseph's Son* is an example of trying to work with a religious theme in a contemporary way.

Develop Some Detective Skills
Learn to examine a painting and take it apart to determine how the materials were used, what the artist did first, what he did second, and so on. If you can reconstruct the procedure, then you can get an insight into what the artist was thinking when he painted it.

▲ **"Joseph's Son"** 48″×65″
The historical idea that I borrow is obviously the story of Jesus' crucifixion. What may not be obvious is that the painting is a combination of the story of the crucifixion and a personal experience in my life. When I was eighteen I worked in Germany for the summer. While there I saw a room where Jewish sympathizers had been hung on meat hooks by the Nazis. Later, when I was an adult, an older friend shared his memory of having seen someone crucified in a concentration camp. This painting contains elements of all three events. I don't know what it means to others. Most of my Jewish and Christian friends don't like it. I like it; for me it is a statement about anti-Semitism. As an artist you have to take risks; no risks, no insights.

▲ **"Jenny's Toys"** 14″ × 15″
Private collection
This is one of several still lifes I did in which the source of light was included in the painting. I used my daughter's bed lamp and simply arranged some of her toys around it.

▲ **"The French Quarter"** 19″ × 21″
Collection of Sue Bryant
I found this store in the French Quarter in New Orleans. At first I saw these cityscapes just as big still lifes. I was intrigued by the quality of the pink light coming from the window. When a man stepped out of the store and stood there on the corner, it added the human touch that was needed.

Variations on a Theme

To explore a variation on a theme means to modify that theme, to change it. Here are some of the ways ideas can be changed: Change the size. Do a bigger version or a smaller one. Change the arrangement of shapes or proportions—this may mean exploring the same subject from a different angle or in a different pose. Change color relationships. To explore variations generally means to pursue a theme.

The best example I have of exploring a theme is how I got involved with painting cityscapes at night. One idea led to another. First I did a painting of a woman standing next to a lit table lamp. I liked the way it turned out and did several more of people standing next to lamps. Then I did several paintings of still lifes with lamps in them. *Jenny's Toys* is an example.

After a while I started to look for found still lifes with lights in them. I went out at night searching for illuminated store windows with interesting window displays. Over weeks and months, I began to notice the little world around the store windows which I discovered was limited by how far the light penetrated the darkness. I started prowling the streets at night looking for interesting buildings and other subject matter. By the time I painted *The French Quarter*, I had pursued the theme so far, it was no longer apparent that the process started with a person standing next to a lamp. Most people assume I was inspired by Hopper or Whistler, two other artists who have played with night themes, but it didn't come about that way at all.

Finally this story has come full circle. Out of this interest in painting city scenes at night have come several paintings at dusk and paintings of the city during the day. *Cheong Trading Company* is the most recent chapter in this story of following a theme. In the end, following a theme is like following

your nose. You never know what tasty things you will discover.

When something really grabs me, I am driven to explore the theme further. I suppose this desire to pursue a theme reflects a desire to understand myself. Each variation on a theme brings me a little closer to understanding who I am and how I respond to the visual world.

Fury of Kenny and *The Thinker* are two of about five paintings I did of Kenny E., a student of mine. While he was studying with me I observed his natural tendency to clown. I hired him to model. It seemed like a rare opportunity to explore humorous themes. Kenny's imagination was stimulated by props, so I brought along a pair of my son's diving goggles, my daughter's tam and whatever else I could think of; then I sat back to see what he would create with them. Even the five paintings I did of Kenny didn't exhaust the possibilities.

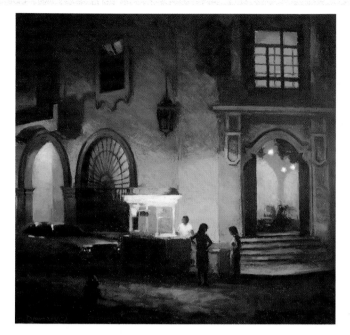

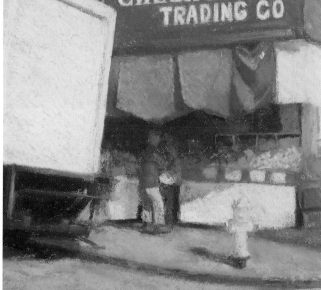

▲ **"Hotel Manzanillo"** 33″ × 34¾″
Private collection
As I took the idea of including lights in paintings further, I began to explore the variety of moods and feelings of the city at night. Though *Hotel Manzanillo* is clearly not of a typical American city, the cloak of darkness somehow gives it the universally recognizable feeling of a city at night.

▲ **"Cheong Trading Company"** 20″ × 20″
Out of my interest in painting cities at night came an interest in cities at dusk and finally in cities in daylight. *Cheong Trading Company* is the most recent chapter in this story of following a theme.

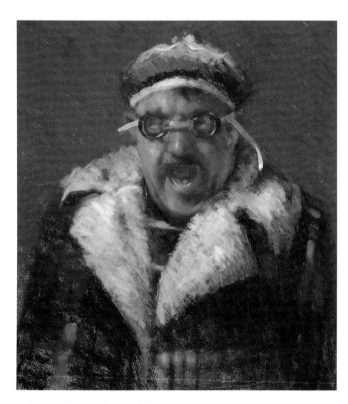

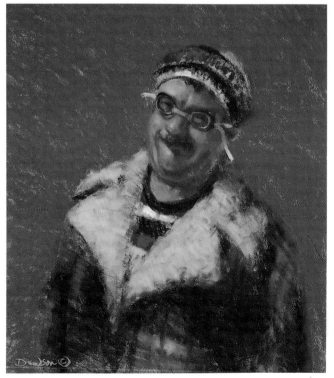

▲ **"Fury of Kenny"** 26″ × 20″
Collection of Mr. and Mrs. Eldon McIntyre
My first painting of Kenny is shown in the chapter on combining techniques. With each successive painting I became more familiar with his proportions and features and a little freer to explore his humorous gestures.

▲ **"The Thinker"** 28″ × 24″
The Joe Dawson Collection
Playing with humorous subject matter presents interesting problems. I would probably not have regarded it as fine art were it not for the vision of the great illustrator, Norman Rockwell.

▲ **"Crossing the Bridge"** 22″ × 24″
Collection of Art-Talk, Inc.
There is a quaint little mining town called Silver Plum not too far from my home. It is filled with little gingerbread houses. After I painted this view, I explored another variation. It struck me that this painting of a mountain town somehow reminded me of a New England seascape. Perhaps it is the style of architecture, or the structure of the bridge, which is somehow reminiscent of a pier. For whatever reason, I refer to this painting as my mountain seascape. I like the feeling, and I am trying to understand it so I can explore it further.

Paint What You Know

In every part of the country there is subject matter that has a regional flavor. Some of this gets ignored because it is thought to be trite. But subjects aren't trite just because they're regional. For a long time I avoided painting mountain themes and mountain villages. I assumed without looking that everyone was painting them, and they were, after all, regional—as if

something were wrong with regional themes. Then one day I looked around. No one was working with this subject matter. It not only wasn't overdone, it was hardly done at all. I suspect there is subject matter all over the country that is being ignored for the same reason. When I was last in New Orleans I looked to see if I could find any good paintings of the bayous. I couldn't. In New York I have looked

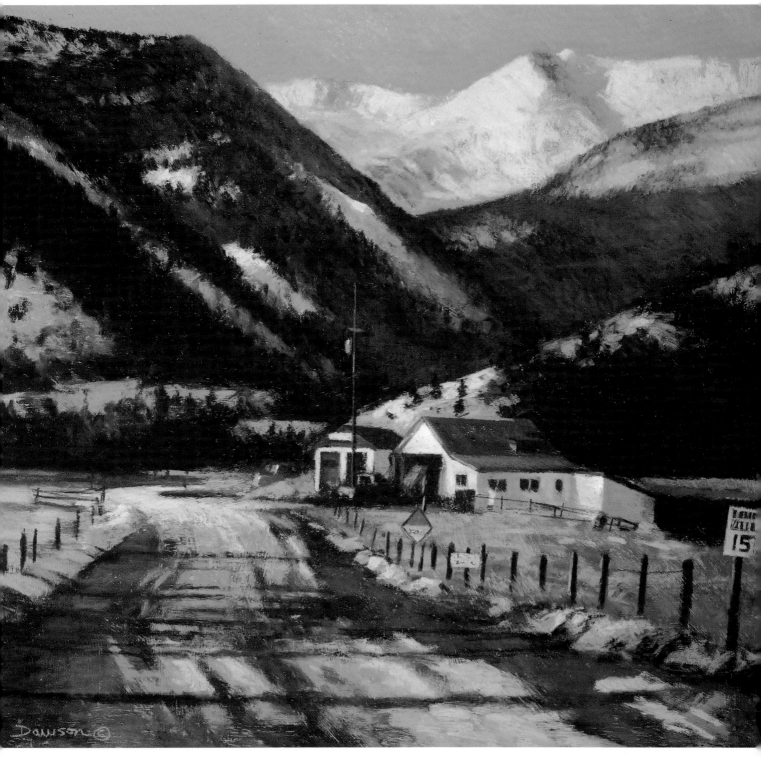

▲ **"Tolland"** 33″ × 36″
Private collection
Mountains are so grand it is obvious that no painting can do them justice. To try to take advantage of their splendor almost seems like cheating. For me they were an untouchable subject. I had painted intimate landscapes I found in the mountains but never a larger view of the mountains themselves. This was the first painting I did trying to challenge my assumption.

for paintings of the inner city. Once again, with very little luck. What I now realize is that we often don't see the best subject matter because it is right under our noses. More than once I've heard the advice given to writers to "write about something you know." Well, that is good advice for painters as well. Look around, and paint something you know. *Crossing the Bridge* and *Tolland* are both paintings inspired by the Colorado mountains. This is part of my backyard and it has special meaning to me.

Reexamine "Inappropriate" Subject Matter

Sometimes very exciting work comes out of painting subject matter we assumed was inappropriate, tasteless, offensive or too insignificant to warrant our attention. It is worth reexamining all of these assumptions because some of them are going to be false. I had assumed it was best to avoid cars in a painting because a car would date the art. I have heard the same thing said about avoiding styles of dress. In *The Used Car Lot*, I went ahead and explored this theme despite my assumptions. I don't know for sure, but I think the painting will survive the test of time.

The sun, the moon and rainbows are generally regarded as subjects for children and more sophisticated artists stay away from them. I have learned a lot about color by painting the sun over the last few years. It now occurs to me to keep my eyes open for rainbows.

Look Back at Old Work

One way to set a direction for yourself is to look back over what you have done. You can ask important questions such as: Of all the drawings and paintings I have done, which one or two do I like best? Why? If you think

▲ **"The Used Car Lot"** 17″ × 19″
Collection of Leo Kreingel

▲ **"Minnesota Sundown"** 14″ × 15″
Private collection

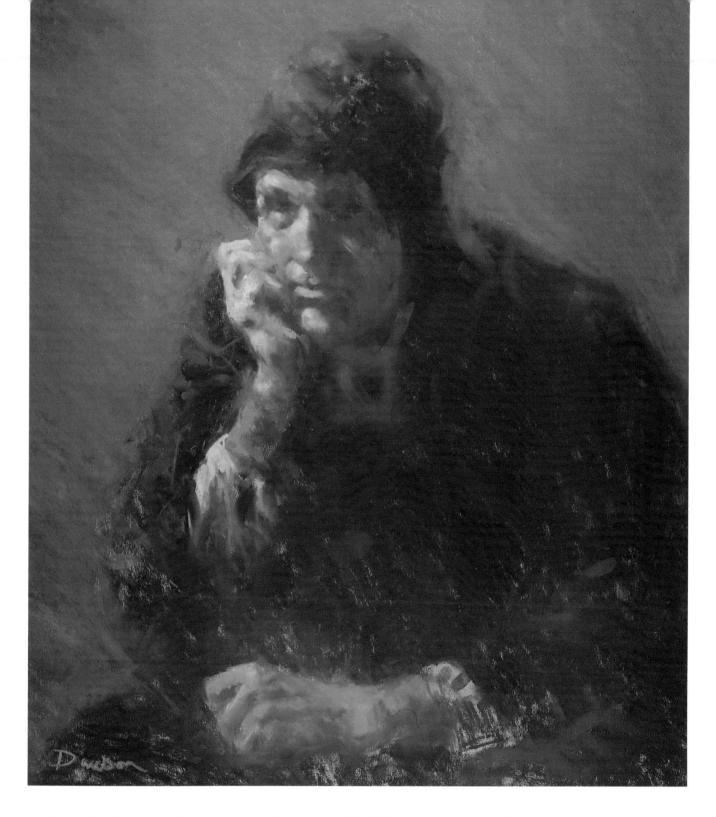

▲ **"Tim"** 26″ × 22″
Collection of W. Simon

you know why, do a few variations on the theme and see if you like those as well. By looking back and picking out those few pieces of work you like the best, you can set a compass course for the direction you want to take with your future work. *Tim* was one of those pivotal paintings in my life. When I looked back at it and several other paintings, I realized I liked the paint-ing because I could still feel something in the pit of my stomach when I looked at it. I concluded that I wanted to con-tinue to explore my emotional re-sponse to people.

Don't stop exploring your re-sponses to all aspects of life and art. You *can* capture with your pastels the light and color of life through your own unique vision.

Index